The
Outdoor Photographer's
Bible

The Outdoor Photographer's Bible

H. Lea Lawrence
Aubrey Watson

DOUBLEDAY
NEW YORK LONDON TORONTO SYDNEY AUCKLAND

PUBLISHED BY DOUBLEDAY
a division of Bantam Doubleday Dell Publishing Group, Inc.
1540 Broadway, New York, New York 10036

Doubleday and the portrayal of an anchor with a dolphin
are trademarks of Doubleday, a division of Bantam
Doubleday Dell Publishing Group, Inc.

Library of Congress Cataloging-in-Publication Data

Lawrence, H. Lea 1930
 The outdoor photographers's bible/H. Lea Lawrence,
Aubrey Watson.—1st ed.
 p. cm.
 ISBN 0–385–48220–5 (pbk.)
 1. Outdoor photography. 2. Nature photography.
 I. Watson, Audbrey, 1942– . II. Title
TR659.5.L38 1997
778.7' 1 — dc20 92-21940
 CIP

April 1997

10 9 8 7 6 5 4 3 2 1

First Edition

Contents

ACKNOWLEDGMENTS

The authors wish to acknowledge the assistance of the following individuals and organizations: Pam Waller, Karina McDaniel, George Brandt, Jessica Brandt, Ron Rice, Sam Jordan, Louis Martins and the owners of Dury's, Tennessee Wildlife Resources Agency and Florida Department of Commerce/Division of Tourism.

Introduction

Outdoor photography is one of the most popular hobbies among Americans, and interest in it continues to expand rapidly. There are many reasons, but paramount among them is that it's an activity in which anyone can participate, whether it be photographing a songbird on a feeder in an urban backyard, a herd of zebras in the bush country of Africa, a delicate wildflower, a magnificent mountain peak or any of a thousand other subjects.

Some of the earliest photographers, in the late 1800s, were taking outdoor photographs, although at that time the equipment wasn't well suited for the purpose, and developing an image was an intricate and time-consuming procedure. Some of the first outdoor scenes that inspired photographers, such as the magnificent western subjects captured by Ansel Adams and others, were taken with large-format cameras that were heavy, cumbersome and required professional expertise to operate.

What finally made amateur photography an "everyman's hobby" was the appearance of George Eastman's famous Brownie camera in 1897. It used flexible roll film that could be processed at home or by commercial labs at a very low cost. The Brownie quickly became standard equipment on family vacations and field trips for taking photographs of scenery and other nature subjects.

Following the Brownie was a succession of different camera styles and film sizes. Twin-lens and single-lens-reflex cameras that used 120 film, both fairly large in size, were very popular. Next came a generation of smaller 35mm viewfinder cameras that dominated the scene for many years.

The most important breakthrough which had the greatest impact on modern photography was the development of the

compact 35mm single-lens-reflex camera and the zoom, mirror and long-focal-length lens. And it was this advancement that made it possible, and practical, to manufacture cameras which are quite affordable and extremely easy to use. The term "so simple a child can do it" is truly applicable to the "point-and-shoot" cameras which automatically meter light, focus the lens, advance film and rewind it when all of the frames have been taken. Furthermore, there are even disposable cameras, which although not suitable for serious photography, produce acceptable pictures.

This book will explain and illustrate the best equipment for outdoor photography, the techniques for taking top-notch photos, and the various problems and challenges presented by a wide range of subject matter.

The
Outdoor Photographer's
Bible

1

Cameras

Any camera can be used to some degree for outdoor photography, but the most versatile is a 35mm single-lens reflex, commonly referred to as SLR.

Single-lens reflex describes a viewing and focusing system where viewing, focusing and picture taking are all achieved through the camera lens. This is accomplished with a moveable mirror and a prism. When the photographer looks through the camera, the image seen is formed by the lens that is mounted on the camera. The image is reflected off a mirror and onto a ground-glass focusing screen and through a prism. The image on the focusing screen is turned forward, righted by the prism and seen through the camera's viewing window. The image that reaches the film is upside down and backward. When the camera's shutter-release button is pressed, the hinged mirror swings up and the shutter opens to expose the film. When the shutter closes, the mirror returns to its original position behind the lens. This all occurs in a fraction of a second (see Chapter 4).

SLR 35mm cameras are small and light, and accept roll film with 12, 24 and 36 exposures. Cameras equipped with special backs and bulk rolls of film can make up to 200 exposures.

CAMERA AND FILM SIZES

The numerical description of photographic equipment may at first seem confusing, but when you learn the terminology it becomes quite simple. Camera numbers indicate the size of film that is used in them. Large-format view cameras hold sheets of film that measure 4 by 5 inches; these are referred to as "Four by Fives." Other view cameras hold film that measures 8 by 10 inches and are called "Eight by Tens."

Medium-format cameras are known as 120 cameras and use roll film that measures 60 centimeters in width. Cameras using the

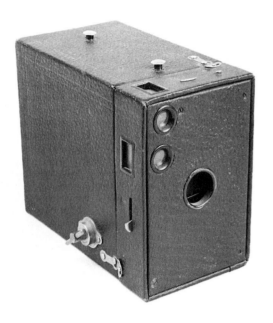

The Brownie camera, first patented in 1897, was manufactured by the Eastman Kodak Company. It holds roll film and has only two settings, one for time exposures and one for normal. The Brownie has three lens openings located in front of the lens. Instead of a diaphragm it has a sliding gate with holes of different sizes that are changed by sliding the gate up or down. The shutter is also in front of the lens. Scenes are viewed through two periscope-like viewfinders, one in the top of the camera for vertical scenes and one in the side for horizontal scenes. These simple, inexpensive cameras are also durable. Even though the camera shown here is nearly one hundred years old, it is still in perfect working order.

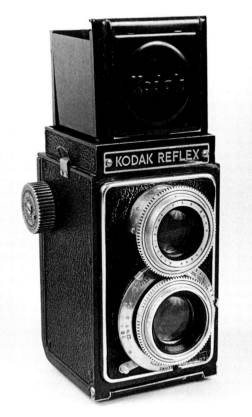

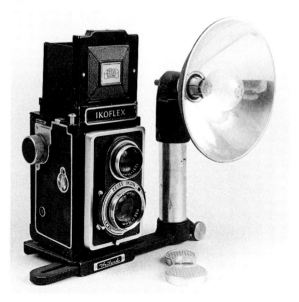

Kodak made this twin-lens reflex in the 1940s. It held 620 film, which is the same size as 120 film, and took a photo 2¼ inches square.

An early model twin-lens-reflex camera from Germany, the Ikoflex, manufactured by Zeiss Ikon, has very good lenses and will synchronize with flash bulbs or electronic flash. The top lens is for viewing and focusing via a mirror and ground glass; the bottom lens is mounted in a shutter for taking the picture. The camera shown here is fitted with a Heiland flash-bulb holder.

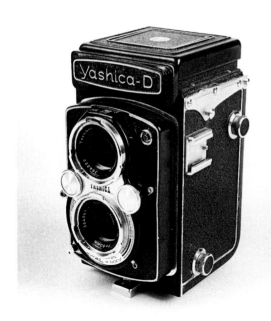

Yashica Twin Lens Reflex cameras are inexpensive and well made. This model D was introduced in the U.S. in the mid-1960s. Current models are similar in design and operation.

same size film may be described as "Six by Seven" or "Six Forty Five," meaning that the image area on the film measures 6 by 7 or 6 by 4.5 centimeters. Numeric designation is often a part of the name of medium-format cameras such as "Mamia 645," or "Pentax 6x7."

Some medium-format cameras use a longer roll of film (220), which is twice the length of 120 film. Most of these cameras make 10 to 12 exposures on a roll of film. The disadvantage of medium-format cameras for outdoor photography is that they are heavier, offer fewer accessories and use film which provides fewer exposures.

The 35mm camera was originally designed to hold motion-picture film that measures 35mm in width. The images produced by a 35mm still camera measure

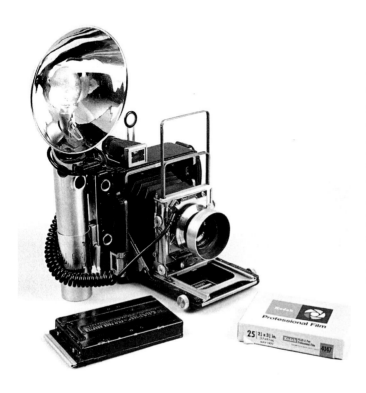

At one time the Graphic rangefinder camera was the standard for news photographers. The most popular size was the 4x5. This camera folds into a compact unit, yet holds sheet film up to 4x5 inches. There were two models, the famous Speed Graphic and the less expensive Crown Graphic. Shown here is a small version of the Crown Graphic, from around 1955, that uses 2¼ x 3¼ sheet film. Also shown is a holder for a film pack that contained 16 sheets of film.

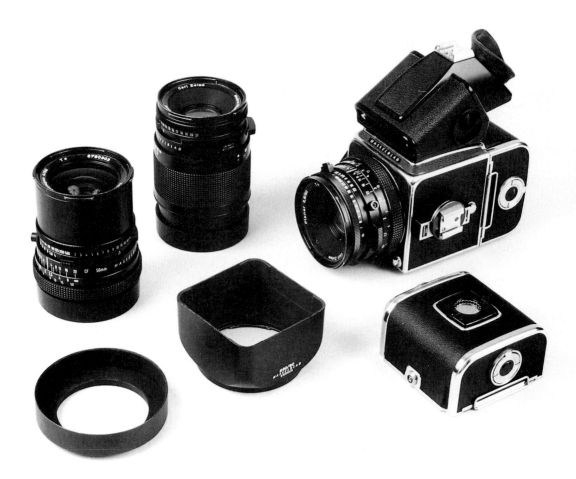

The Hasselblad, made in Sweden, is the finest and most expensive of the medium-format single-lens-reflex cameras. Shown here is a camera with an 80mm (normal) lens and a prism viewfinder in place. Also shown are a 50mm lens (wide angle on a camera of this size) and a 120mm lens and their respective lens hoods. The boxlike device near the camera is a 12-exposure film magazine. The photographer can load several of the magazines with different kinds of film and change backs as needed.

24mm by 36mm. The image width measures less than 35mm because the film has sprocket holes that are used to transport it through the camera. Roll film (120) does not have sprocket holes; therefore the image area on roll film can be nearly as wide as the film.

Modern 35mm cameras have motorized film-advance mechanisms, built-in light-metering systems, computerized exposure systems and electronic focusing (autofocus). They are by far the most popular cameras on the market today, and there is a wide array of accessories avail-

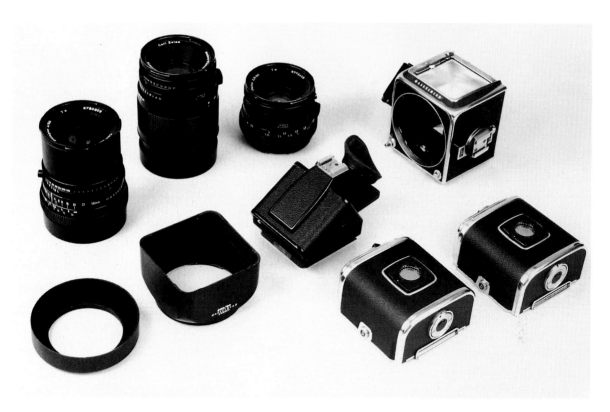

The modular design of the Hasselblad camera makes it easily adaptable for a photographer's individual needs. Most of the photographs from NASA spacecraft are taken with these cameras. Shown here are a camera body, prism viewer, 50, 80 and 120mm lenses, lens hoods and two 12-exposure film magazines.

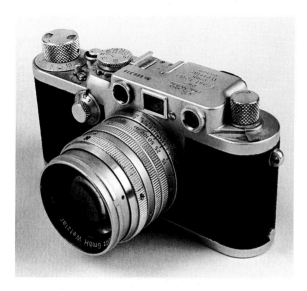

The first 35mm camera was designed in Germany in 1912 by Oskar Barnak. It used 35mm motion picture film with an image size of 24 x 36mm, the same size as today's 35mm cameras. Barnak perfected his camera after World War I. The first camera based on Barnak's design was the Leica, put into production by Ernst Leitz Company of Wetzlar, Germany, in 1925. The name is derived from LEitz CAmera; the original name LECA was changed to LEICA. The camera shown here is a Leica model lllf introduced in 1950. It has flash synchronization and shutter speeds from 1 second to 1/1000 of a second.

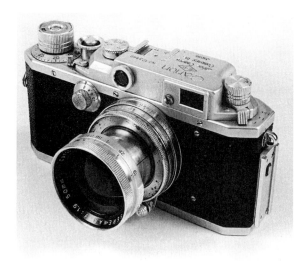

This Canon rangefinder camera from the 1950s has many of the features of the Leica and costs less. The lenses were interchangeable with Leica lenses. Canon cameras then, as now, were of high quality.

able for the more sophisticated models, which is what makes the 35mm system ideal for outdoor photography.

At this writing, electronic cameras that record still images on computer drives are coming into use. These consist of standard camera bodies that have been modified and equipped with a full range of lenses and flash equipment. The computer portion of the camera resembles a motor drive. The technology is called digital imaging because the images have been converted to a series of numbers based on a binary code.

Located on the part of the camera normally occupied by film is a Charge Couple Device (CCD) which captures the

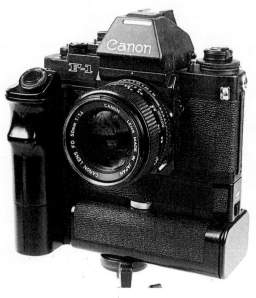

The rugged Canon F-1 typifies the modern professional SLR camera, shown here with a 50mm normal lens and a motor-drive film advance. This camera can be customized by the individual photographer with changeable viewing screens (ground glass), film advances, lenses and exposure systems.

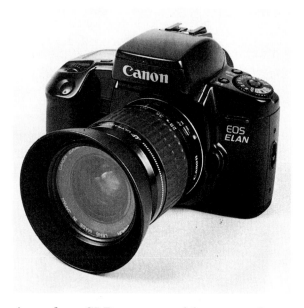

A modern SLR camera with an autofocus 28–85mm zoom lens and multiple automatic and manual functions. These cameras and lenses are made of lightweight materials and function well in extreme climatic conditions due in part to their sophisticated electronics and fewer mechanical parts.

SLR OPERATION

Viewing and Focusing Position

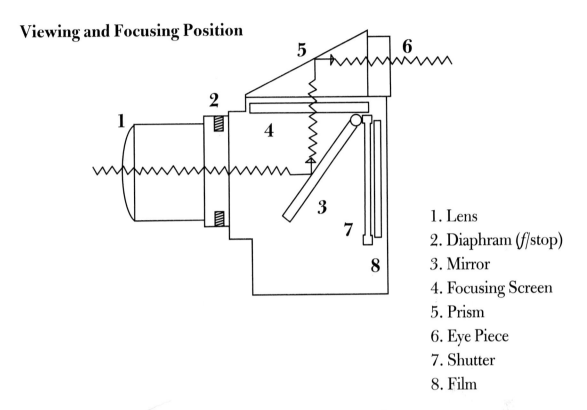

1. Lens
2. Diaphram (*f*/stop)
3. Mirror
4. Focusing Screen
5. Prism
6. Eye Piece
7. Shutter
8. Film

Exposure Position

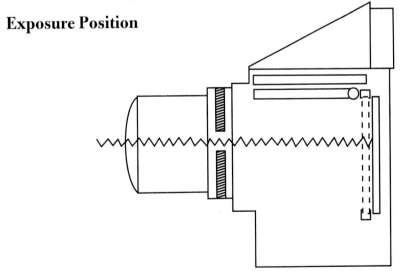

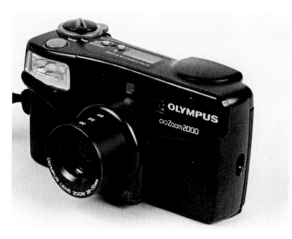

"Point-and-shoot" cameras share many automatic functions with the larger SLRs. The Olympus shown here has a 38–60mm power zoom lens, automatic, center-weighted exposure system, built-in electronic flash and power film advance and rewind.

image from the camera lens in much the same way a video camera captures an image. The information gathered by the CCD is sent to the camera's computer. Instead of processing film, the photographer connects the digital camera to a larger computer where the images are displayed. From there the images can be transferred to 3½-inch diskettes. From these the image can be reproduced as conventional prints or imported directly into a magazine layout. The quality of photographs taken with digital cameras does not approach that of conventional photographs, but nonetheless, computers may replace film in the future.

A point-and-shoot camera is an excellent choice when weight and storage are factors. Scenes such as this are easy to capture with a compact camera.

2

Lenses

Like cameras, lenses are designated numerically. The numbers indicate the focal length. Focal length is a term that defines the optical value of a lens. The standard lens on a 35mm camera has a focal length of 50mm. Standard lenses are also known as normal lenses. A lens with a smaller number such as 24mm is a wide angle, and a lens with a larger number such as 200mm is a telephoto.

Cameras larger than 35mm have a larger lens, but the formula is the same: smaller numbers indicate wide angle; larger numbers indicate telephoto. Lenses are all designated numerically and should not be confused with the numeric designation of other photographic equipment. A 35mm camera equipped with a 135mm or 55mm lens is still a 35mm camera.

WIDE-ANGLE LENSES

Wide-angle lenses for 35mm cameras come in focal lengths that range from super-wide 17mm to slightly wide 35mm. Two good focal lengths for outdoor photography are 24 and 28mm. Large-format cameras use wide-angle lenses which are of longer focal length. For example, on a medium-format camera that makes an image 2¼ inches in width, a 50mm lens is a wide angle, yet the normal lens for a 35mm camera is a 50mm. The focal length of a normal lens in any format is equal to approximately the diagonal measurement of the image on film. For example, the diagonal measurement of a 35mm camera's film image is about 44mm and the normal lens is 50mm. Any lens with a focal length less than 44mm is a wide angle. The diagonal measurement of a 4x5 image is 150mm; therefore a normal lens for a 4x5 camera would be 150mm in focal length and a wide angle would be 90mm. The easy way to choose a wide-angle lens for any camera is to be sure its focal length is less than the diagonal measurement of the image on film.

The angle of view of 24mm and 28mm

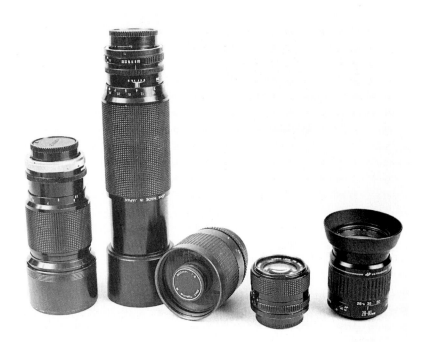

Several lenses for 35mm cameras that are suitable for outdoor photography. Left to right: 200mm *f*/2.8 lens; 100–300mm *f*/5.6 zoom lens; 500mm *f*/8 mirror reflex lens; 24mm *f*/2.8 lens; 28–80mm *f*/3.5–5.6 autofocus zoom lens.

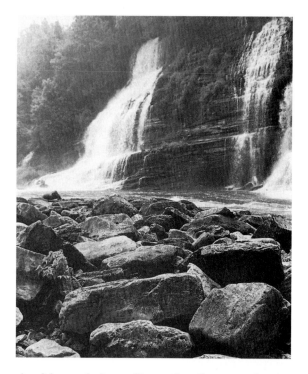

A wide-angle lens allows the photographer to include both foreground and background in a photograph. This scene was taken with a 24mm lens. A small *f*/stop (*f*/16) rendered the rocks, as well as the waterfall, in sharp focus.

lenses is respectively 84 and 75 degrees. This wide field of view makes wide-angle lenses ideal for large vistas and for photographing interiors.

ZOOM LENSES

Zoom lenses were designed in France for use on motion-picture cameras, but they are now highly popular with still photographers. These lenses have complicated internal mechanisms that vary the focal length of the lens. Typical examples are 28mm–70mm and 70mm–210mm. This is performed by sliding or turning a sleeve on the lens. The method of zooming the lens may be different on some lenses, but the principle is the same.

Zoom lenses are convenient because they can be used in place of several lenses

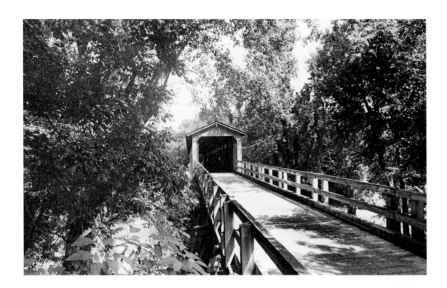

This scene of a covered bridge was taken with a 24mm wide-angle lens.

With the camera secured on a tripod, the 24mm lens was replaced with a 50mm lens, generally referred to as a normal lens on a 35mm camera.

This photograph was taken by replacing the 50mm lens with a 135mm telephoto lens.

(contunued)

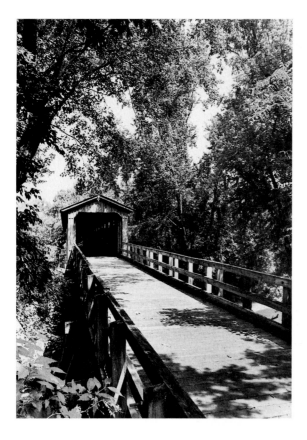

The same scene (top left) was taken in a vertical position, this time with an autofocus zoom lens. This photograph was taken with the zoom lens in the wide-angle position of 28mm.

The lens was "zoomed" (top right) to the 50mm position for this photograph. The camera was not moved.

This photograph (left) was taken with the zoom lens in the 80mm position. The advantage of a zoom lens is obvious: One lens can replace three or four lenses of fixed focal length.

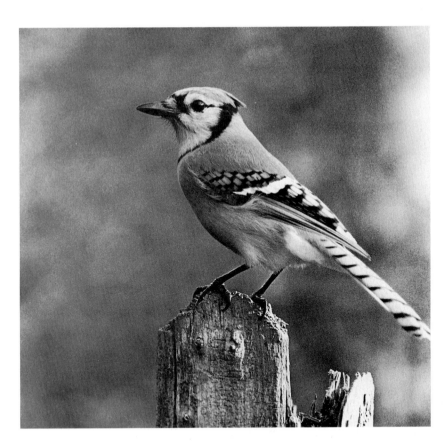

This blue jay was photographed from a blind with a 300mm lens at a distance of about ten feet.

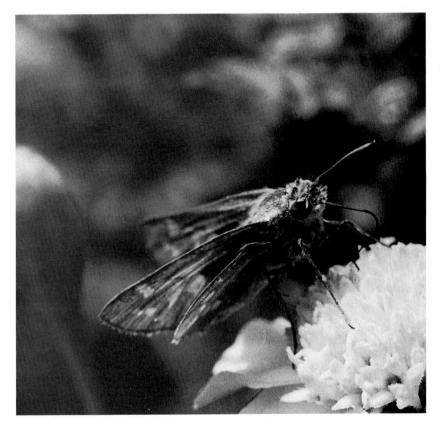

This close-up of a skipper butterfly was taken with a 200mm lens and an extension tube. The extension tube fits between the lens and camera and allows the photographer to focus the lens closer to the subject than normal.

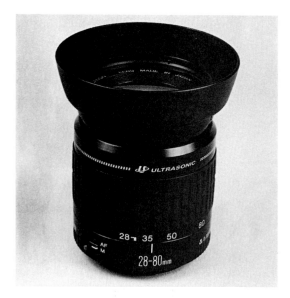

This 28–80mm autofocus zoom lens can also be focused manually. Its compact size is typical of modern autofocus lenses. This lens also has macro capabilities.

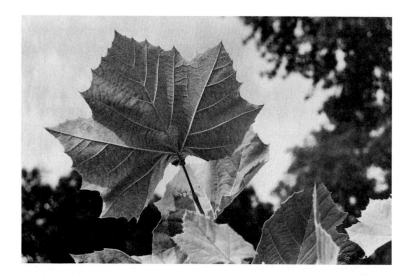

When used correctly, an autofocus lens is accurate and fast. This tulip poplar leaf is in sharp focus because it was in the focusing target.

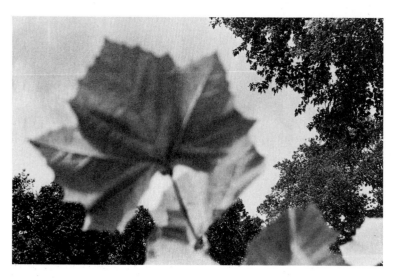

The same scene was taken with the focusing target on the wrong subject; thus the main subject is out of focus while the background is sharp—a common problem when the photographer is careless.

of fixed focal length. Some zoom lenses have features that allow the photographer to make close-up as well as normal and telephoto photographs.

One disadvantage of zoom lenses is that they have smaller maximum apertures and do not transmit as much light as fixed-focal-length lenses. A zoom lens may have a maximum aperture of $f/4.5$ compared to a fixed lens that may have a maximum aperture of $f/2.8$ or larger. Another drawback is that since zoom lenses transmit less light, focusing in dim conditions may be difficult. A slower shutter speed or faster film may be required to make a photograph in low light (see Chapters 3 and 4).

There are three types of macro lenses: macro zoom, normal macro and tele-macro. These lenses are very sharp and can be used as normal lenses. A tele-macro will allow full-frame photographs of subjects like bees or spiders while working at a comfortable distance.

Macro lenses have smaller maximum apertures than non-macro lenses of comparable focal length. A normal lens may have a maximum aperture of $f/1.4$, while a macro lens may have a maximum $f/$stop of $f/3.5$. In most situations the difference is not critical to getting the photograph. A slower speed or faster film may be used.

MACRO LENSES

Macro lenses are designed to take close-up pictures without the aid of accessories.

TELEPHOTO LENSES

Lenses of focal length ranging from 135mm to 1200mm are referred to as tele-

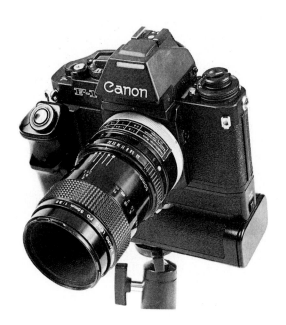

Macro lens on a Canon F-1 is mounted on an extension tube that extends the lens's close-focusing capabilities to about 2 inches.

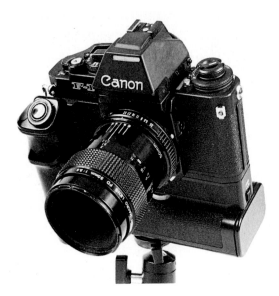

The 50mm macro lens mounted on this Canon F-1 camera can take photos 8 inches from the subject.

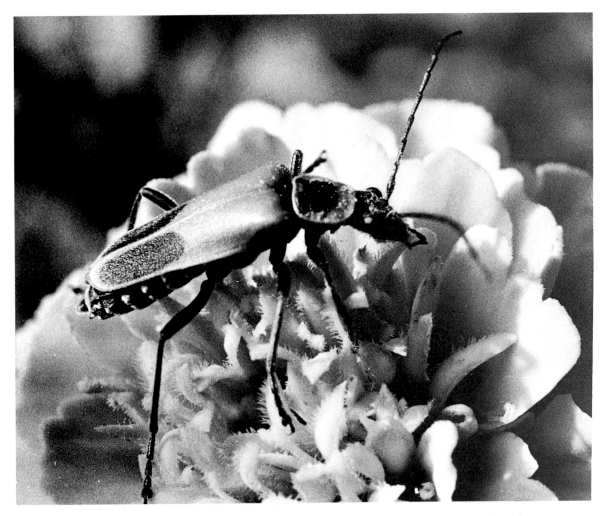

This Pennsylvania leatherwing beetle was photographed with a 50mm macro lens.

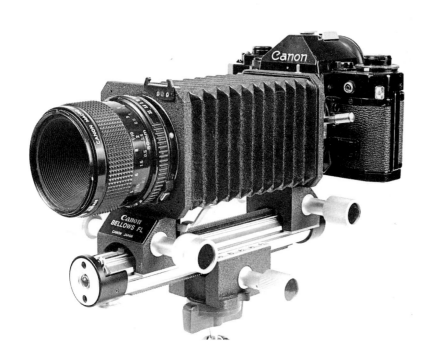

A bellows extension between the macro lens and the camera body enables the photographer to take extreme close-up photographs.

photo. These lenses magnify the subject and can produce soft backgrounds. A telephoto lens will reproduce the same image as a comparable zoom lens, but a modern telephoto lens may have a larger maximum aperture. The larger maximum aperture of some telephoto lenses makes them easier to focus and use in dim light. They are particularly good lenses for nature photography, especially when a fast shutter speed is required.

The magnifying power of any long-focal-length lens can be compared to the standard, or normal, camera lens. With a 50mm lens as standard, a 500mm lens would have the magnification of 10 times the normal view.

Often novice photographers think that a telephoto lens will allow them to work at great distances from the subject. This is not always true. Consider the size of the subject relative to the power of the lens and the distance from the photographer to the subject. If a 300mm lens is used to photograph a moose, the photographer can work at a considerable distance from the subject. Yet if the subject is a songbird, the photographer, using the same 300mm lens, will have to be within 8 to 10 feet of the subject to fill the frame.

DEPTH OF FIELD

In addition to determining the amount of light that passes through the lens, the *f*/stop also affects the area of sharpness in a photo. When a lens is focused on one object, everything in front of and behind that object will be out of focus to some degree. That zone of sharpness is described as depth of field, which is deter-

A 500mm mirror-reflex lens mounted on a Canon 5-1. Mirror lenses are very small and lightweight. Lens elements commonly used in most lenses have been replaced with mirrors. Mirror lenses cannot be adjusted; they do not have a diaphragm. The lens shown has a constant stop of $f/8$. To adjust exposure with one of these lenses, the shutter speed on the camera must be changed.

A 200mm $f/2.8$ lens. The large front element transmits more light than the smaller element of a $f/4.5$ telephoto lens.

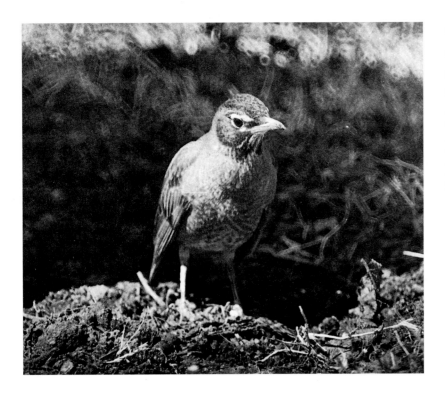

This robin was photographed with a mirror-reflex lens. Notice the circular highlights in the out-of-focus background. These "doughnut" highlights are common in pictures taken with mirror-reflex lenses.

This 100–300mm *f*/5.6 lens is a good choice of zooms. Its versatility and moderate cost make it a favorite among outdoor photographers. Such lenses can be bought secondhand from reliable camera dealers.

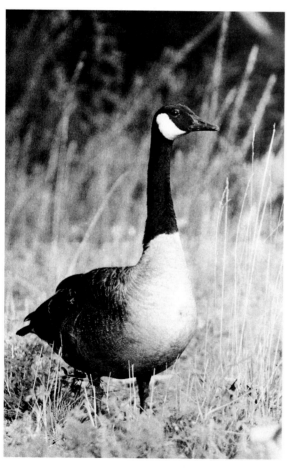

Canada goose was photographed with a 100–300mm zoom lens at about the 200mm position.

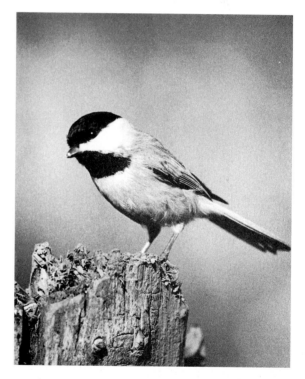

Carolina chickadee captured with a 200mm lens and a 2-power extender. These devices fit between the lens and the camera body and increase the magnification of the lens. Extenders require as much as one stop additional exposure. When a 2-power extender is used on a 200mm *f*/2.8 lens, the lens becomes a 400mm *f*/5.6.

For outdoor portraits, the best choice is a medium telephoto or zoom lens. The perspective of this portrait taken with a 70–150 zoom lens in about the 135 position is natural and pleasing. The background is rendered out of focus by the short focusing range of the long lens. A large *f*/stop (*f*/4.5) kept depth of field to a minimum.

Proper care of a lens is critical. This photographer is using a Leupold Lens Pen to remove dust. Lenses should only be cleaned with lens tissue, brushes and liquid that are made for the purpose. Never use silicone-treated tissues or cloths.

mined by the size of the aperture to which the camera is adjusted (*f*/stop), the focal length of the lens, and the distance from the camera to the subject. Depth of field will vary with lenses of different focal lengths. A wide-angle lens will have more depth of field than a telephoto lens at the same *f*/stop and shooting distance. However, if the subject size remains the same in the picture and the shooting distance changes to accomplish this, then the depth of field will be the same no matter which lens you use (see diagram page 32).

When working with subjects that require high magnification, it is important to have maximum depth of field. Critical focusing with telephoto and macro lenses is difficult, and having sufficient depth of field can correct small errors in focusing.

Three factors must be taken into consideration when adjusting the controls of your camera: shutter speed to arrest action; aperture to adjust the amount of light that is passed through; and depth of field. To achieve the desired depth of field, choose the *f*/stop and then adjust the shutter speed to the appropriate setting to get the correct exposure.

It is not always possible to have maximum depth of field; neither is it always desirable. Certain conditions may limit the use of a small *f*/stop: subject movement which requires a fast shutter speed or dim light, which requires a larger *f*/stop. Also, you may want to blur a distracting background to emphasize the main subject. Artistic interpretation can make the difference between a snapshot and a good photograph, and controlled depth of field is a valuable tool.

In order to see the depth of field you can use the depth-of-field preview feature on the camera. The position and operation of the depth-of-field preview control differs with various models and manufacturers, so you may need to refer to the instruction book that came with the camera. In most cases, the control is either a lever or a button.

To use depth-of-field preview you must focus on the main subject and turn the *f*/stop ring to *f*/16 or *f*/22. In photographic terms this is known as "stopping down." You then actuate the depth-of-field preview control and will see in the viewfinder the depth of field. As you look through the viewfinder you can turn the *f*/stop ring from minimum to maximum *f*/stop and see the effect it has on the depth of field. When stopped down to the smallest *f*/stop, less light is transmitted through the lens and the image may be difficult to see, but a good indication of the depth of field is provided.

Depth of field can also be calculated by using the scale on the lens. To perform this, focus the lens on the main subject, then look at the distance index on the lens. On either side of the distance index are repeated numbers representing *f*/stops. By comparing two identical *f*/stop numbers on each side of the index to the distance scale, you can determine the depth of field at any *f*/stop.

Control of depth of field is not possible with all lenses. Reflex telephoto lenses do not have aperture adjustments. These

DEPTH OF FIELD VS. FOCAL LENGTH

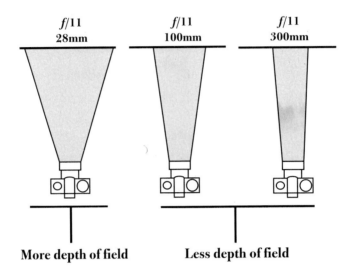

Less depth of field

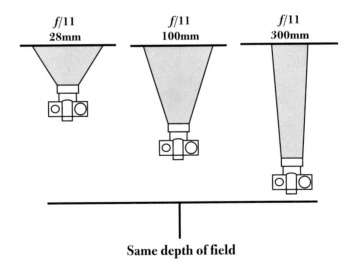

Same depth of field

lenses are usually 500mm or 1000mm and designed with internal mirrors. The use of mirrors allows the manufacturer to construct a telephoto lens that is smaller than conventional lenses of comparable focal length. Reflex lenses have a fixed aperture of $f/8$ or $f/5.6$. Exposure adjustment is accomplished by changing the camera shutter speed to correspond with the fixed $f/$stop of the lens.

The chart on page 34 illustrates the depth-of-field scale on the camera lens. When this scale is used, depth of field can be planned and the appropriate $f/$stop chosen.

In example *A* the lens is focused at a distance of 10 feet. The $f/$stop selected is $f/11$. The center scale indicates that the depth of field range is from 4 feet to 30 feet. This is determined by comparing $f/11$ on both ends of the scale to the focusing distance. On the left side, $f/11$ corresponds with 4 feet, and on the right side $f/11$ corresponds with 30 feet. The center mark is the focused distance.

Example *B* indicates a depth of field from 3.5 feet to infinity at $f/16$ still focused at 10 feet, while example *C* shows a depth of field range from 6 feet to 15 feet at $f/8$. This can be found by looking at $f/8$ on the scale and noting the corresponding distances on either side of the focusing mark.

In example *D* the lens has been stopped down to $f/22$ and the lens is focused at infinity. By finding $f/22$ on the depth-of-field scale it is easy to see that the depth of field range in this instance is from 5 feet to infinity.

The last example, *E,* is a close-up situa-

tion with minimum depth of field. At $f/8$ the depth of field is from 2 feet (the focus point) to 2.5 feet. If the lens was stopped down to $f/22$ the range would extend to 4 feet.

FOCUS

Focusing a single-lens-reflex (SLR) camera is done by turning the focus ring until the subject becomes sharp and clear. The image seen through the viewfinder of an SLR is formed by the same lens that takes the picture. You can't see the depth of field unless you stop down the lens and use the depth-of-field preview.

In order to keep the image in the viewfinder bright enough to compose and focus, the aperture of the lens remains at its maximum $f/$stop until the shutter release is pressed. At that time the lens diaphragm closes to the $f/$stop to which the lens has been adjusted (see Chapter 4).

In outdoor photography it is often necessary to focus quickly, and this can be made easier by pre-focusing. To pre-focus you will need to anticipate where the subject is going to be when you take the picture and focus on that point. Sometimes this will permit fairly wide latitude in regard to depth of field, especially when the subject will be at a distance of 20 or more feet. In closer situations where you know the general area in which the subject will be, focus on an object close by and when it is time to take the picture, only minor focusing adjustments may be necessary.

Autofocus cameras can be used effec-

DEPTH-OF-FIELD SCALE

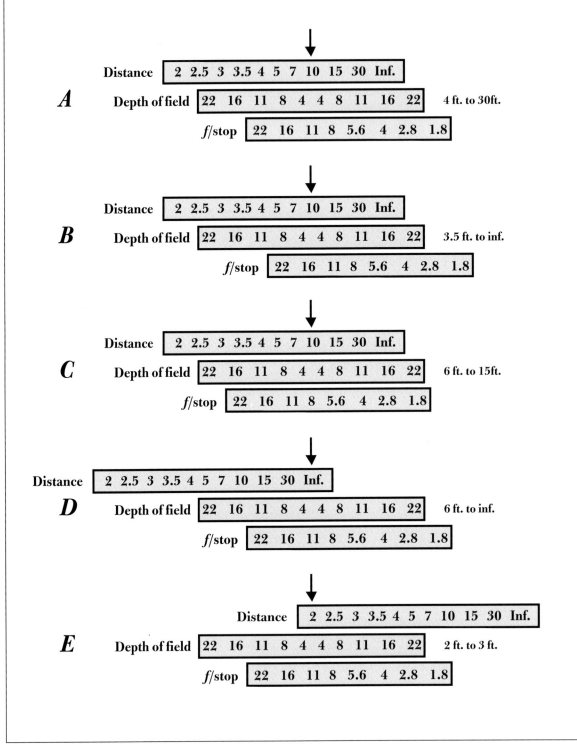

tively for outdoor photography if you understand how the system works. The design and function of autofocus lenses vary from one brand of camera to another, and you will need to familiarize yourself with the model you own.

One thing to remember is that the camera knows how to focus, but it doesn't know where to focus. Automation is based on the camera's sensors, which gather information and make adjustments through the use of microcomputers.

Autofocus cameras have an autofocus frame that can be seen in the viewfinder. Whatever is in the frame will be in focus when the picture is taken. If your main subject is not in the autofocus frame, you can aim it at the subject and lock it in focus. This is done by using the focus lock control, which is accomplished on some cameras by pressing the shutter release button halfway down and holding it there while you recompose the scene and take the picture.

Autofocus, like all automatic features of a camera, may not work under all conditions, and you will need to switch to manual control. For some situations, though, you can compose and take the photograph without regard to focus or exposure. You will have to judge the conditions in which you are working and choose the mode that will give you the best results.

CLOSE-UPS

There are several ways to make close-up photographs of nature subjects, the simplest of which is to move in close with a normal lens. This works very well if the subject is large. Remember the example given earlier of a moose and a songbird? Close-up photography works the same way. A photograph of a moose taken with a 50mm lens at a distance of 10 feet is a close-up view of a moose. However, a close-up view of a bumblebee with a 50mm lens must be made at a distance of 1 or 2 inches. Most 35mm cameras have a minimum focusing distance of about 24 inches. Therefore, to make close-up photographs with a normal lens it must be modified either mechanically or optically.

A mechanical modification is one in which you increase the distance from the rear element of the lens to the film. This is accomplished by using either an extension tube or a close-up bellows between the camera and the lens.

To modify the lens optically a close-up supplemental lens is attached to the front. This supplemental lens is sometimes misnamed a close-up filter because of the resemblance, but it is properly called a close-up lens or a close-up attachment. Many close-up lenses are available in different optical values and can be used singularly or in combinations. There are also some designed specifically for long-focal-length lenses.

Care should be taken when choosing supplemental lenses, because the image from one of inferior quality may not be sharp. This will be evident in the edges of a photograph taken with a large lens opening. When the lens is stopped down, the flaws may not be evident. When com-

pared in price to a normal lens, even the best supplemental lenses are inexpensive, which is a good reason why the serious photographer should take care in selecting supplemental lenses that will not degrade images. An advantage of supplemental lenses is that when attached they do not require any change in exposure.

Extension tubes and close-up bellows are not as critical as lenses because they do not contain any glass elements, but there are still factors to consider. Both should allow the camera's automatic exposure system, or metering system, to function. A close-up bellows should have a double cable release, which enables the photographer to work with the lens at maximum aperture. This is knows as an "auto-bellows." With some cameras it is possible to have automatic exposure with a bellows by stopping down the lens and allowing the camera to set the correct shutter speed. Refer to the instructions for your camera and bellows. Most close-up photography can be accomplished with devices other than bellows, which are ordinarily used for extreme close-up work.

When using a bellows, extension tube or a macro lens at full extension, the additional distance from the lens to the film results in a loss of intensity in the light reaching the film. This light loss requires a slower shutter speed or larger lens opening.

The amount of increase in exposure time or f/stop can be determined in two ways. On either the bellows focusing rail or on the extension tube is a series of numbers that indicate the amount of exposure increase necessary for correct exposure.

There are also numbers that indicate the amount of enlargement of the main subject. If an object is photographed full size the numbers will indicate a ratio of 1:1. If the subject is photographed one-half size, the scale will indicate a ratio of 1:2.

The best way to determine exposure with extension tubes is with the camera's metering system. Since the camera meter reads light that passes through the lens, there is no need to calculate exposure increases. Care should be taken to meter properly (see section on exposure, Chapter 4). If the main subject is of a natural tone the indicated exposure will probably be accurate. If the main subject is light or dark, the exposure may not be correct, in which case the use of a gray card to meter the subject is appropriate. When a gray card is not practical, shoot the indicated exposure and bracket the f/stops or the shutter speed, as explained in Chapter 4.

Macro lenses, alone or in combination with extension tubes, are the most practical means of taking close-up photographs. These lenses also can serve as normal lenses. There are several versions of macro lenses which are explained elsewhere in this chapter.

Telephoto and zoom lenses work well for taking close-up pictures of subjects that are difficult to approach. Many telephoto lenses have minimum focusing distances of 5 to 10 feet. The focusing distance of a long lens can be reduced by attaching an extension tube between the lens and the camera.

When taking close-up photographs with macro lenses, the movement of the subject and the photographer are exagger-

ated, just as they are with telephoto lenses. A good rule of thumb when using a macro lens at full extension and the camera is hand-held is to multiply the focal length by four and set the shutter speed nearest that number for a minimum setting. If the macro lens has a focal length of 55mm, the shutter speed should be 1/250 second; if the lens is 100mm, 1/500 second is the right shutter speed. Use a tripod for macro photography to allow you to shoot at slow shutter speeds. A monopod is better for photographing moving subjects such as butterflies since it allows you to change positions more rapidly.

One problem that frequently occurs in macro photography is movement caused by the wind. Even a slight breeze can move a flower, and when viewed through a close-up lens, the movement is highly exaggerated. There are several ways to solve this problem. A wind screen can be erected, but this may sometimes cast a shadow on the subject. Another is to tie the flower to a stake driven into the ground. If the breeze is too strong and the flower still sways, try using both the wind screen and the stake. Better yet, wait for the wind to stop.

FILTERS

Filters serve three purposes: to correct, enhance or change an image. Those used with black and white film may darken a sky or lighten foliage. Filters for color photography are sometimes employed to balance the light source with the film (see section on color temperatures in Chapter

3). For example, daylight color film is balanced to a color temperature of 5500 degrees Kelvin, which is blue. Tungsten film is balanced to 3200 degrees Kelvin, which is red. If you use tungsten film outdoors the picture will be blue. To correct the color you would use a red filter, which looks like a color between amber and orange and has a designation of 85B. This causes the light that reaches the film to be the same color as the light from a photoflood light or motion picture light to which the film is balanced.

Inversely, if you use daylight film under tungsten light the picture will be red, so you use a blue filter over the lens or the light source, which will make the light that reaches the film the same color as daylight (blue). This filter is designated 80A.

Warming Filters

Warming filters absorb various amounts of blue and range in color from light reds (skylight) to amber colors (81A and 81B). They should be used with discretion because they affect the color of the scene. However, these filters can enhance color when the sky is overcast or when the subject is in shade.

Filters for black and white film are yellow, orange or red, which absorb blue in different degrees. Therefore, when a large sky area is photographed through one of these filters it is darkened, causing white clouds to be enhanced. On the other hand, if a scene with green trees is photographed with a green filter, the trees will be a lighter tone of gray.

The scene above was taken without a filter. The same scene, below, was taken with a polarizing filter. The sky has been darkened and the clouds remain white.

One filter that is used for both color and b/w film is a polarizing screen. It is a neutral glass filter which has no color, yet isn't exactly clear. A polarizing screen is mounted on a moveable ring so that it can be rotated while it is mounted on the lens. When the light is coming from a point at a right angle to the camera, the polarizing action will remove the glare from reflective surfaces. It can also darken sky areas. Polarizing screens can be used in combination with other filters.

There are three basic kinds of filters: thin acetate filters, called gelatin filters, which require special holders; round glass filters, which are threaded and screw into the camera lens; and square plastic filters, which are mounted in special holders.

Most square filters produce special effects, such as two colors, star bursts, soft focus, multiple images and so forth, and have no place in serious outdoor photography.

The most commonly used filter is the round glass type. These filters are designated by their diameter, which corresponds to that of the lens on which they will fit and by their function.

Many lenses of the same manufacturer, but of different focal lengths, will accommodate filters of the same diameter. It is possible to have a lens system of, say, 55mm that will range from 24mm through to 70–150mm zoom and use the same filters. Reflex telephoto lenses have filter thread at the rear of the lens, and filters for these lenses are small, usually 35.5mm in diameter.

Lenses and filters are designated numerically and should not be confused. The focal length of the lens and the diameter of the filter are not the same. As just mentioned, a 24mm lens holds a filter of 55mm.

Haze Filters

The truth about haze filters is that they don't filter out haze. Haze is caused by

Two filters—a yellow and a polarizer—were combined to create a dramatic effect on black and white film. The yellow filter absorbed blue in the sky, enhancing the darkening effect of the polarizing screen.

smoke, water droplets, automobile exhaust and other particles suspended in the air. The effect of haze on a photograph can be lessened somewhat by using an ultraviolet (UV) filter, which is commonly referred to as a haze filter. The blue color seen in a photograph that is taken when conditions are hazy is diffused ultraviolet light. The filter absorbs the ultraviolet and in doing so diminishes the visual effect of the haze. Photographs taken with long-focal-length lenses exaggerate the effect of haze, so it is important to use a UV filter. Other colors can be seen in haze when there is air pollution present. Yellow skies, for example, can be corrected with a light blue filter.

Exposure with Filters

When a filter is used on a camera that has a built-in exposure system, the loss of light is compensated for because the camera is measuring light that is passing through the filter. If you are using a hand-held meter or a flash, the exposure must be adjusted to take into account the filter's light absorption. In order to correct for exposure, each filter is assigned a "filter factor," a number which can be found on the technical sheet packed with each new filter. A simple way to decide corrected exposure is to divide the ISO by the filter factor and base the exposure on the new number. If the flash calls for an exposure of $f/16$ with a film rated at ISO 200 and the filter factor is 2, divide 200 by 2 and take a reading with the meter adjusted to ISO 100. The film is still 200 and is processed normally.

The other way to correct exposure is to translate filter factors into f/stops. A factor of 2x equals one f/stop ($f/11/2x=f/8$). The following table illustrates corrected exposures.

Most of these adjusted numbers aren't on the camera lens. The clicks between the f/stops will be close to one of the odd numbers. Set the lens as near as possible to the number. When the adjusted number is 11.3, set it to $f/11$, and if the number is 13.0, set it midpoint between $f/11$ and $f/16$.

NORMAL EXPOSURE: f/STOPS										
	1.6	2.0	2.8	3.5	4.5	5.6	6	11	16	22
Factor					*New Lens Setting*					
1.5x	1.4	1.6	2.3	2.9	3.7	4.6	6.6	9.2	13.0	18.5
2x	1.6	1.4	2.0	2.5	3.2	4.0	5.6	8.0	11.0	16.0
2.5x	1.8	2.2	2.8	3.6	5.2	7.1	10.1	14		
3x	1.6	2.0	2.6	3.3	4.6	6.6	9.2	13.1		
4x	1.4	1.7	2.2	2.8	4.0	5.6	8.0	11.3		
5x	1.6	2.0	2.5	3.6	5.0	7.0	10.1			

Here's a quick summary of filters commonly used in outdoor photography and their purpose.

Polarizing screen. Removes glare from reflective surfaces, darkens sky. Use with color or b/w film.

Ultraviolet (UV). Lessens the blue caused by scattered ultraviolet light. Good for long-focal-length lenses. Also, because it is clear, it is good protection for a lens.

Skylight. Use only in shade or on overcast days to warm the color of a scene. Do not use as lens protection.

Yellow. Use with b/w film to darken sky and improve contrast in bright sun.

Natural Density (ND). These filters have no effect on the color of a photograph. They only absorb light. ND filters are available in several values and are numbered. They can be used as an alternate to stopping down a lens or changing the shutter speed. They are also available in graduated filters in which one half is gray and the other half clear. These filters work well when a sky is bright and the foreground is dark.

Sunshades

A sunshade is another accessory that will improve the quality of your photos. This simple device reduces glare and improves contrast. It is standard equipment on the lenses of professional photographers.

To see the benefit of a sunshade, put your camera on a tripod outdoors and place a filter on the lens. Then walk around to the front of the camera and look at the filter. You can see the sky reflected in the glass filter. Now attach a sunshade and repeat the process. You will see that the sky's reflection is gone and the filter is dark and clear.

Modern lenses are coated to minimize glare, but this coating is only good when the lens is without a filter. When an uncoated piece of glass is catching light it decreases contrast and degrades the image. Even without a filter the coated lens has limitations. Put simply, a sunshade can greatly improve your photographs, so consider it a part of the main team.

3

Film

Artists as far back as Leonardo da Vinci were aware of the phenomenon of the projected image. He described the camera obscura, or dark room, where the image of the scene outside could be projected through a pinhole onto the opposite wall inside the room. The camera obscura evolved into a small box with a ground-glass back and a lens. Artists could then make accurate drawings by placing tissue paper over the ground glass and tracing the image. A similar instrument, the Camera Lucida, or "Lucy," was used until recently by commercial artists.

In the ensuing years, many attempts were made to capture the projected image on paper without having to make a drawing. Sometime around 1800, Thomas Wedgwood, son of the famous English potter, found that paper coated with silver nitrate would turn black when exposed to light. Wedgwood placed objects on the treated paper then exposed it to sunlight until the paper turned black. When the object was removed, a white silhouette could be seen on the paper.

The image was short-lived, however, because when the unexposed area was exposed to light, it also turned black. Wedgwood gave up his experiments due to ill health, having failed to fix (make permanent) the images.

Years later in France, Louis Jacques Mandé Daguerre discovered a means of fixing silver images. His Daguerreotypes, first introduced in 1839, were made by plating a sheet of copper with silver nitrate, then buffing it to a mirror finish. He would then expose the plate to iodine vapors, creating light-sensitive silver iodide.

After exposure in a camera obscura, the plate was developed with mercury vapors after which it was fixed in a solution of sodium chloride (common salt). Today,

Glass plate negatives from around the turn of the century.

This outdoor portrait, taken in the early 1900s by an amateur photographer with a view camera and glass plate negatives, shows remarkable tone and detail.

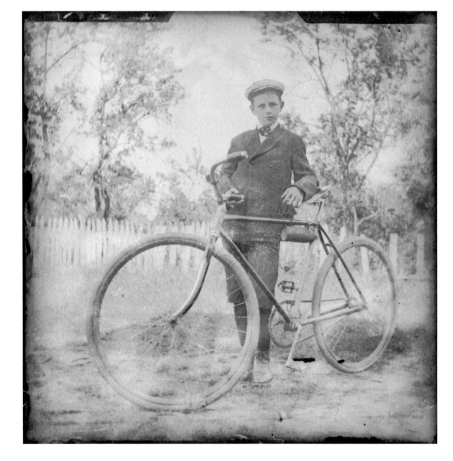

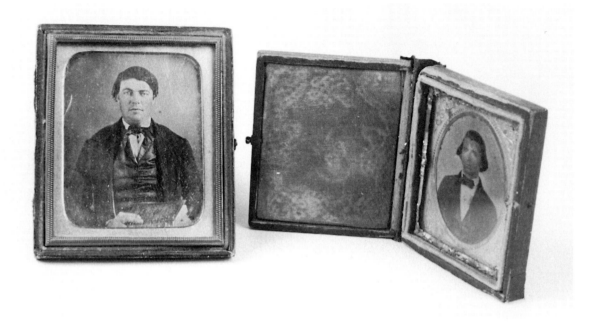

The photograph at left is a Daguerreotype and the one at right a tin-type. Daguerreotypes were actually highly polished sheets of silver-plated copper that were sensitized by exposure to iodine fumes. The iodine fumes converted the silver to light-sensitive silver iodide. After exposure in a camera, the plates were developed by exposing them to mercury fumes. After development the image was fixed (made permanent) by a bath of sodium thiosulfate (fixer), basically the same fixer that is used today. Tintypes have an emulsion on a metal surface and lack the luminescence of Daguerreotypes.

most photographs are fixed in sodium thiosulfate or ammonium hyposulfite, both referred to as "hypo" or "fixer."

Daguerreotypes were replaced by glass negatives, made by coating a sheet of glass with an emulsion of albumen (egg whites) containing suspended silver salts. These negatives required very long exposure and never became universally popular. Albumen negatives were replaced by collodion plates.

Collodion is a viscous solution of nitro-cellulose in alcohol and ether. Collodion quickly dries to form a tough waterproof film. It was first used medically for protecting minor skin cuts. Potassium iodide was added to collodion, which was then coated onto a sheet of glass. The coated glass plate was next dipped into a solution of silver nitrate. The silver ions combined with iodine ions to form light-sensitive silver iodide within the collodion. The glass plates had to be exposed when they were wet. Later, wet plates were replaced by dry

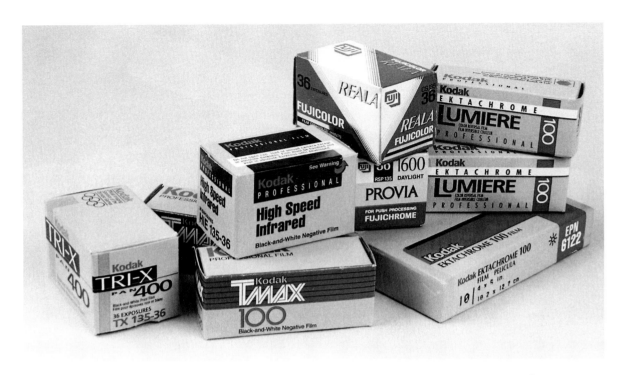

Today photographers can choose from many films to suit just about any situation.

plates coated with a gelatin and silver emulsion, which were similar to modern films.

A major advance was made in 1888 when George Eastman introduced his famous Kodak camera and flexible celluloid film. Although it has undergone considerable refinement, Eastman's invention remains the basis for modern photographic film: silver suspended in an emulsion; coated onto a transparent base; developed with chemicals; and washed with water.

Today's photographer is fortunate in having available many kinds of film. There are three kinds used in general photography: b/w negative film from which b/w prints are made; color negative film from which color prints are made; and color transparency film (slide) film, which is also referred to as reversal film.

All films are rated based on their sensitivity to light. The rating is expressed numerically, as an ISO (formerly ASA in America and DIN in Europe). ISO is the acronym for the International Standards Organization. A low number such as ISO 25 means that the film is less sensitive to light, and a high number such as ISO 400 indicates high sensitivity. The metering system of the camera must be set to the proper ISO, although most modern cameras self-adjust to the correct ISO automatically.

Films with lower numbers are generally called slow films and those with higher numbers, fast films. In the language of photography, ISO is referred to as the film speed.

Slow films produce photographs with

Four kinds of film: top, 35mm negatives; from left, medium format 2¼-inch-square negative; 35mm transparency (slide); 4x5 color transparency.

fine grain and extreme sharpness, which means that either transparency or negative film can be reproduced very large without sacrificing quality. They may require long exposure, a large *f*/stop or both. Fast films allow for a shorter exposure time and smaller *f*/stops while sacrificing fine grain. Slower films are the best choice under optimum lighting conditions and minimum subject movement.

In bright sunlight measuring 320 footcandles on an incidence light meter, the following shutter speed-*f*/stop combinations are correct exposures for films of seven different ISO ratings.

Color films are also designed for use under different light sources. The color of light is measured in degrees of Kelvin. The color temperature of daylight with full sun is 5500 degrees Kelvin, which is also the color temperature of the light from an electronic flash. Color film designed to render correct colors in 5500 light are designated as Daylight Film.

The light from a household bulb is about 2900 Kelvin, and the light from a

ISO RATINGS FOR SHUTTER SPEED-*f*/STOP COMBINATIONS

ISO	25	50	100	200	400	800	1600
Shutter Speed	f	f	f	f	f	f	f
1	90*						
1/2	64*	90					
1/4	45*	64	90				
1/8	32	45	64	90			
1/15	22	32	45	64	90		
1/30	16	22	32	45	64	90	
1/60	11	16	22	32	45	64	90
1/125	8	11	16	22	32	45	64
1/250	5.6	8	11	16	22	32	45
1/500	4	5.6	8	11	16	22	32
1/1000	2.8	4	5.6	8	11	16	22

* The minimum *f*/stop on most camera lenses is *f*/22 or *f*/32. View camera lenses may stop down to *f*/45, *f*/64 or *f*/90.

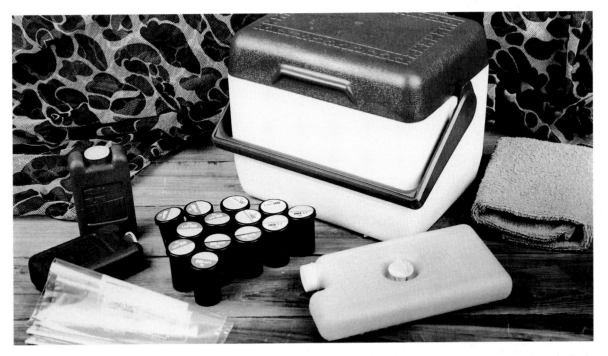

Proper storage and handling of film in the field is critical. An insulated cooler is the best way to carry film, especially in hot and humid weather. Reusable ice packs will assure further protection. Resealable food bags keep film dry and organized. A small towel over the film inside the cooler helps to insulate the contents. In humid climates, put a silica-gel pack in your storage bag to absorb moisture.

Kodak Lumiere professional 35mm colorslide film (left) is available in only one length, 36 exposures. Roll at right is Kodak Lumiere in 120 size. Most 120 film is available in two lengths, 120 and 220, for 12 and 24 exposures.

photoflood bulb is 3200 degrees Kelvin. The lower the color temperature, the redder the light will be. Light of a higher temperature approaches blue. The color change will not always be perceptible to the eye because our vision tends to correct colors, but color film will record the differences in color temperatures.

Color films that are used indoors with a photoflood, or tungsten, light are designated as tungsten film and are color balanced to 3200 degrees Kelvin. If tungsten film is used to take a photograph outdoors the image is blue, and if daylight film is used indoors the image is red. Both of these films can be used under opposite lighting conditions by using corrective color filters over the lens, but it is always bet-

ter to use the right film for the light source under which you will be photographing.

Even though most outdoor photographs will be taken with daylight film, a working knowledge of color temperatures is valuable to the serious photographer. For instance, when the sun is low on the horizon the color temperature is lower and the color will shift to red. Both early morning and late afternoon light give color photographs a warm appearance. Because the sunlight is filtered by the amount of atmosphere it must penetrate when the sun is at a low angle to the earth's surface, much of the blue is filtered out. The color temperature of the light is lower; therefore the color of light is warmer. Early morning and late afternoon also happen to be prime feeding times for many wildlife species.

Films have other characteristics such as grain, contrast and color reproduction which need to be considered. Before selecting a film, think of how the final photograph is to be displayed. If your objective is to produce a color print for exhibition or for the family album, the logical choice would be a negative, or print, film. If the photograph is to be published, use color transparency film.

There are circumstances where either of these films can be used. Color prints can be produced from color transparency film by making an intermediate negative (referred to as an internegative), or by printing the transparency directly on reversal print material.

Color prints can sometimes be used for publication. Many newspapers and wire services prefer color prints over trans-

**Taken with Kodak TMAX 100 fine-grain film, this photograph is extreme-
ly sharp and holds details in the white fence planks and in the leaves.**

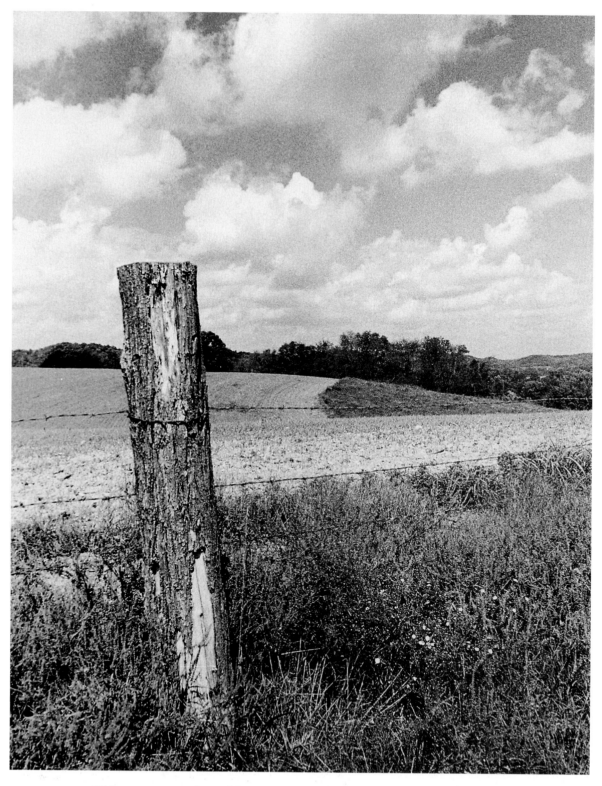

This scene was taken with an ISO 400 film rated at 800 and "pushed."
Grain is noticeable in the sky. In areas of the photograph that have
detail and texture, the grain is not as apparent.

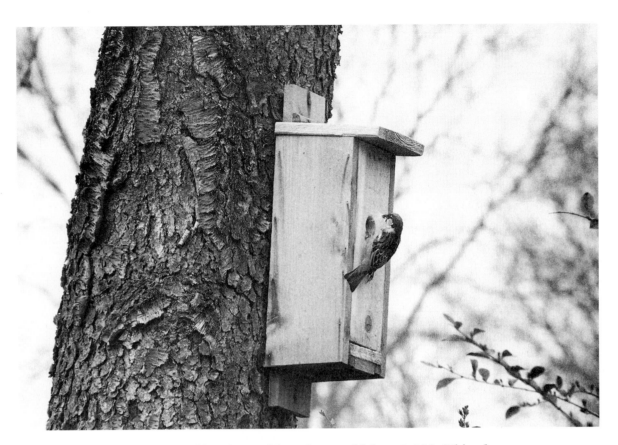

Some modern films have ISO ratings as high as 3,200. This photograph was taken on high-speed film with an ISO of 1,600.

The same photograph enlarged shows the texture of the film's grain. High-speed film should be used only in low light or when the action calls for a fast shutter speed.

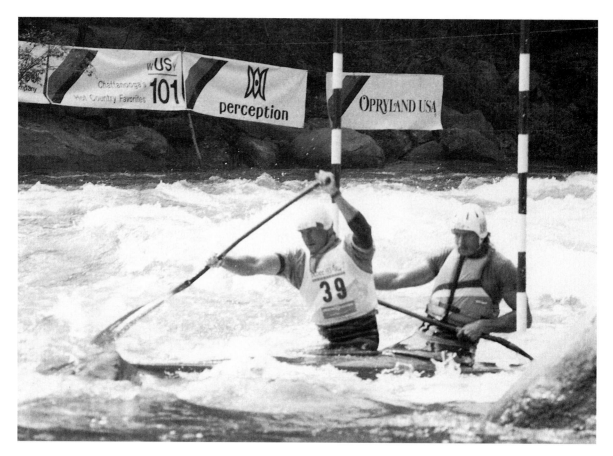

This black and white print was made from a 35mm color negative. The film is Kodak's Kodacolor Gold, ISO 200. Black and white prints can be made from color negatives by a custom photolab or by the photographer using Kodak's Panalure paper.

parencies, while most magazine, calendar and poster publishers prefer transparencies. Color transparencies can also be made from color negatives.

Black and white films render a negative from which b/w prints are made, which are what some publications prefer. B/w prints can be printed from color negatives onto special paper, and also from color slides by making a b/w internegative from the slide, then printing the internegative onto conventional paper. Both of these processes can be done by a professional photo lab or in the photographer's darkroom. Color prints, negatives, slides or b/w prints can be scanned onto a computer disc (digitized), depending on the application, equipment and software.

The following map illustrates the route to get from the film of choice to the final medium.

FILM MAP

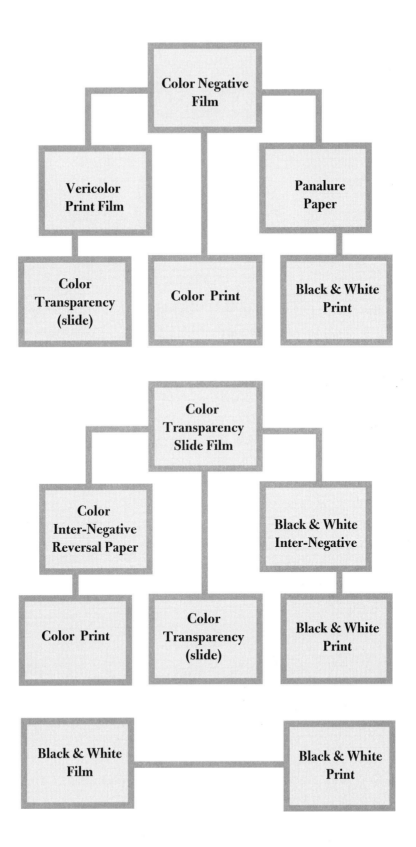

4

Exposure

Basic to all photography is correct exposure of the film. Transparency (slide) films require exact exposure. Negative (b/w and color print) films don't require such exact exposure because certain corrections can be made in the lab when the negative is being printed. The latitude of exposure of negative film is a good safety measure, but it has limitations and the best photographs will be those printed from a correctly exposed negative.

Two factors govern the exposure of film: *f*/stop and shutter speed. *f*/stop refers to the adjustable aperture of the lens through which light passes, expressed numerically.

F/stop settings are indicated on a moveable ring on the lens. The smallest number is the largest opening and the largest number is the smallest opening. A lens opening of *f*/4 will transmit more light than a lens adjusted to *f*/22. These are extreme examples representing the range of *f*/stops on most lenses. These numbers

are determined mathematically based on the focal length and diameter of a lens. Adjustable *f*/stops are achieved with a variable diaphragm that works like the iris of the human eye.

Sometimes the *f*/stop is set to control depth of field and a corresponding shutter speed is selected. Under other conditions the shutter speed is chosen first to stop action and the appropriate *f*/stop is set. Point-and-shoot cameras have neither close-up *f*/stop nor shutter-speed settings.

Shutter speed is actually shutter duration, or how long the shutter remains open. This is expressed in units of time. Most often, these units range from 8 seconds to 1/2000 second. Setting the shutter speed on most cameras is accomplished by turning a dial located at the top of the camera body, or on some of the newer electronic cameras by pressing a button. Point-and-shoot cameras make a shutter speed and *f*/stop selection based on the light reflected by the subject.

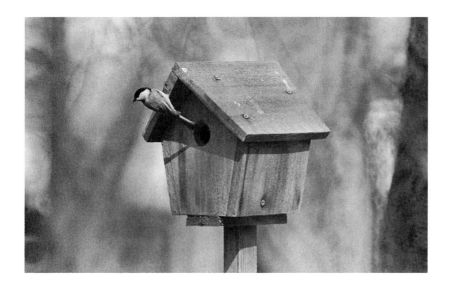

This is a correct exposure determined with an incidence meter measuring the light falling on the birdhouse. The exposure was 1/125 second at *f*/11.

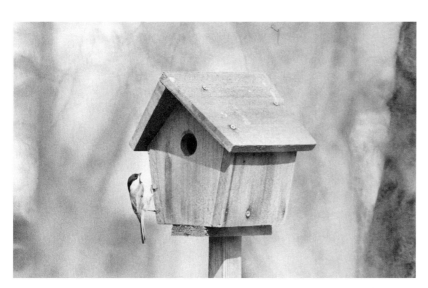

The same birdhouse taken at 1/125 second at *f*/5.6 is overexposed.

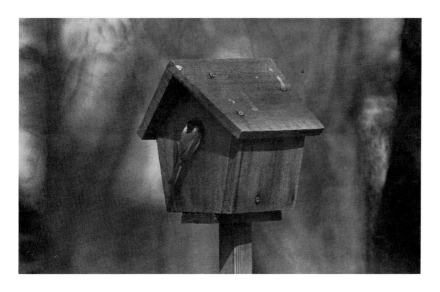

At 1/125 second at *f*/16 the photo's underexposed.

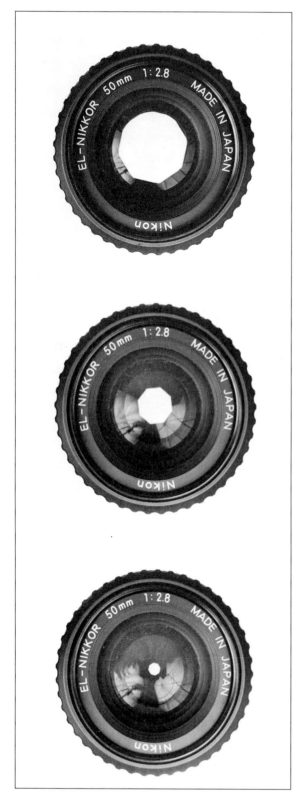

This is an enlarging lens set at three different f/stops (from top): f/2.8, f/11, f/22.

Shutter speed and f/stop also determine other characteristics of the final photograph, such as depth of field and stopping action, which will be explained in detail later in this chapter.

SELECTING SHUTTER SPEED

When taking a photograph, you have to determine the correct shutter speed for the selected f/stop or for the action of the subject. Both of these settings depend on the type of film and the brightness of the light. A slow film such as ISO 25 requires more exposure than a fast film. In bright sunlight, an f/stop of f/22 calls for a shutter speed of 1/15 second. Using a faster film such as ISO 400 in bright sun, an f/stop of f/22 calls for a shutter speed of 1/250 second.

In bright sunlight measuring 320 foot-candles on an incidence exposure meter, the shutter speed required for f/22 with films of different speed can be seen on this table.

Film Rating	Shutter Speed	f/Stop
ISO 25	1/15	f/22
ISO 50	1/30	f/22
ISO 100	1/60	f/22
ISO 200	1/125	f/22
ISO 400	1/250	f/22

Stopping Action

When the first consideration of the photograph is to stop action, the shutter speed is selected first. The action arrested can be either that of the subject or it can be the

action of the photographer. To illustrate photographer's action, mount your longest lens on the camera and then point the camera at a small object. With the camera hand-held, you will see the object moving around in the viewfinder.

The rule of thumb in stopping the action of the photographer is to use a shutter speed that is double the focal length of the lens. For instance, with a 100mm lens, use a shutter speed of 1/250 second. To eliminate camera movement, mount it on a tripod and use a cable release. When the camera is mounted on a tripod the exposure time can be as long as needed for correct exposure provided the subject is not moving.

There are other ways to steady a camera, including the use of a monopod or resting the camera on a sandbag. Another way to suppress camera movement is to attach a heavy string to the tripod socket of the camera using a $1/4$-20 x 1-inch eye bolt from the hardware store. Make a loop in the opposite end of the string, making sure that the string is long enough to allow you to hold the camera at eye level while the loop is around your foot. It should be just long enough to develop tension when the camera is brought to eye level. This will steady the camera, but it works well only with moderate shutter speeds and should not be used for long exposures.

Subject movement may be as subtle as the gentle swaying of a flower stem or as rapid as the wingbeat of a bird's wings or the darting movement of an insect. Both subject and camera movement are amplified in high magnification photography, either macro or telephoto.

There is no rule in selecting shutter speed to arrest subject movement. The photographer simply has to make a judgment call. To be safe, use the fastest shutter speed possible for the film type and the brightness of the light. A shutter speed of 1/125 second may be fast enough to photograph a swaying flower; 1/250 second will stop the action of a subject in motion, such as a running animal; while 1/1000 second will probably stop the action of a bird in flight. On the other hand, stopping the action of a hummingbird's wings will require a shutter speed of 1/5000 second, since they move at a rate of about 55 beats per second. There is a fraction of a second at the top and bottom of the cycle when the wings stop. If you shoot enough film, you may get a picture at one of these critical moments. Shutter speeds of 1/1000 or 1/2000 will produce good results; otherwise the blur of the wings will enhance the effect of movement. Extreme action can be photographed with electronic flashes that have a flash duration of 1/5000 second to 1/10,000 second. Flash duration refers to the time the Xenon gas tube in the electronic flash is illuminated.

MEASURING LIGHT

In order to expose a photograph correctly, you must be able to measure the brightness of the light reflected from the subject or light striking the surface of the subject. Either method of measuring light for exposure will work, but each has its own set of guidelines.

Cameras equipped with light-metering

systems, as well as automatic cameras, measure reflected light. The metering system indicates to the photographer the combination of *f*/stop and shutter speed required to make a correct exposure for the film speed to which the camera has been programmed or adjusted. Setting the ISO on the camera is accomplished manually on some cameras by turning an indicator dial, and on others the ISO is set automatically by the computer reading a bar code on the film cassette.

In the case of programmed systems, the camera's computer makes the necessary adjustments based on light reflected from the subject. Most in-camera metering systems are center-weighted averaging systems, meaning that the overall scene is measured with more emphasis given to the center of the frame. This works well in even lighting but may not be accurate in extreme conditions. When there is an area in the scene that is much brighter than the main subject, as often occurs with back-

lighting, a white background or a large sky area, it is important to move in close to the main subject, take a light reading, then return to your original position and make the photograph. Some cameras have interchangeable focusing systems that can change the metering mode to spot reading. This means that a small area of the scene can be metered. Spot metering is very accurate when used correctly.

There are at least three basic exposure modes common to all electronic systems: aperture preferred, where you select the *f*/stop and the camera sets the appropriate speed; shutter preferred, where you select the shutter speed and the camera sets the correct *f*/stop; and the program mode, in which the camera makes both the *f*/stop and shutter speed selections.

Exposure Meters

There are two types of hand-held meters: incidence meters and spot meters. Inci-

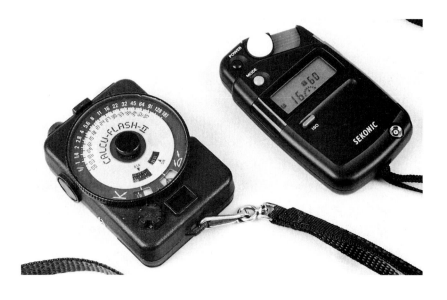

Two exposure meters of different design that read incidence and reflected light: a Calcuflash by Quantum (left) and a Sekonic, a spot meter.

dence meters are used to read light falling on the subject. Spot meters, similar to a camera's light meter, read reflected light. Some meters measure flash, and some measure ambient light as well as flash. All light meters have one thing in common: They are calibrated to a standard reflectance of about 18 percent gray.

Exposure meters are not designed to distinguish color. They read the scene as if it is black and white. The reflected light from a gray card (available at camera stores) is the middle of a total scale that ranges from black to white. The Kodak

The photographer is using the camera's metering system in the manual mode to take an exposure reading on a standard gray card. To get an accurate reading the card must receive light from the same angle as the subject does. Gray cards work well with spot meters.

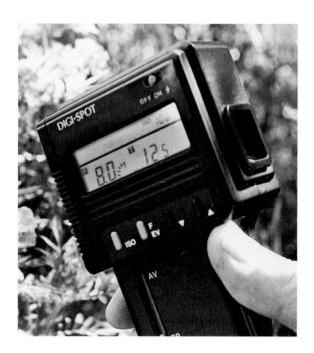

This spot meter has a lens and viewfinder similar to that of a camera. A spot meter can read a small area of a scene and indicate the correct exposure in the viewfinder as well as in the external window. In this photograph the meter was adjusted for ISO 100. It is indicating an exposure of 1/125 of a second at *f*/8 from a reading on a gray card.

standard gray card reflects 18 percent of the light that falls on it. A white card reflects about 90 percent, and a black card reflects almost none. This is important to remember when metering any scene, but it is especially significant when photographing very light subjects such as pale-colored flowers or snow scenes. The camera's meter will read the light reflected from a lightly colored or white subject and indicate an exposure that will reproduce a tone near middle gray, resulting in an underexposed (dark) photograph.

There are several ways to eliminate this problem. One is to hold a gray card in the scene, take a light reading from the card, then make an exposure on the subject.

An incidence meter is held at the subject and pointed at the camera to read the amount of light striking the subject.

You can also use other reflective surfaces to meter an exposure. Caucasian skin reflects nearly the same light as a gray card, and so does a blue north sky, green grass or a weathered gray sidewalk. When photographing subjects of a middle tone, such as an evenly lit green leaf, a direct reading from the camera will almost always indicate a good exposure.

Another way to meter a scene is to use an incidence light meter. These meters are held in the scene and are pointed *toward* the camera. The light falls on the white plastic dome of the meter; and with an

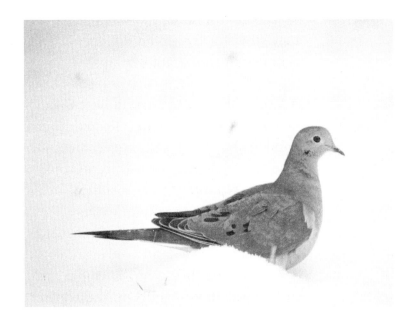

A direct reading through the camera lens would have resulted in an underexposed image of the dove. The camera's meter would have indicated an exposure for the snow based on 18% gray, rendering the snow gray and the subject very dark. For this scene an exposure reading was taken with an incidence light meter. An additional camera reading off winter foliage without snow confirmed the exposure.

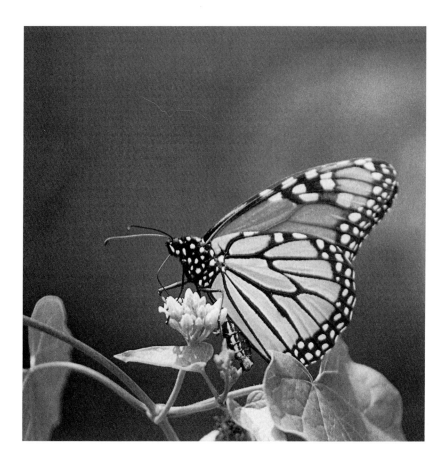

When the background is dark, the main subject can be overexposed by a simple camera exposure reading. In this picture of a Monarch butterfly the exposure reading was taken on the background in an area of medium tone. The gray area above and to the right of the butterfly's wings is a patch of green leaves, out of focus, in sunlight. The tone of the leaves was near 18% gray. The photograph was taken on negative film which has some exposure latitude.

LED or LCD read-out (digital), or a needle and scale (analog), the meter indicates the correct exposure.

Bracketing Exposures

A good way to ensure correct exposure is to "bracket." To do this, take a reading of the scene and make an exposure as indicated by the camera or a light meter. Then select a larger *f*/stop and make an exposure at that setting; next, select a smaller *f*/stop and make another exposure.

For example, if the first exposure is *f*/11 and the shutter speed is 1/250 second, the first bracketed exposure would be *f*/8 and the second one *f*/16. Shutter speeds can also be bracketed when a constant *f*/stop is required to maintain depth of field.

There are cameras today that have automatic bracketing features which can be adjusted for whatever amount is needed.

Some amateur photographers are reluctant to make bracketed exposures, but it is common among professionals, especially when using transparency film. Even with accurate metering, it is an aid in obtaining a correct exposure.

Photographers may find themselves in situations where there is not enough light to make the desired exposure. When this occurs there are three options: use a high-speed film, or "push" the film being used. Pushing is a term used by photographers

In this backlighted scene the main subject is underexposed. The camera was in the automatic mode and made an exposure based on the overall brightness of the scene.

The same scene was exposed with the camera in the manual mode. An exposure reading was taken off the grass in front of the subject.

A closer view of the same scene using flash fill to light the subject. For this exposure the camera was in the program mode and the built-in flash lit the scene.

oped to compensate for the underexposure. When "pulling" film, the opposite is true. Therefore, the whole roll of film must be given the same ISO rating. You cannot change the ISO speed for one or two shots on a roll of film. A one-stop push will double the ISO rating and allow an increase of one shutter speed. Three

This scene was lit with full sun falling on the subject's face. In a situation such as this, automatic exposure will most often render a good exposure. Some of the new cameras have an automatic bracketing feature that will make bracketed exposures in both the manual and auto modes.

for rating film at a higher ISO than normal, then developing the film longer than normal to compensate for the new rating. Push processing can be done in the photographer's darkroom or by a professional film-processing lab. Film can also be *pulled* to lower the ISO and decrease the development time.

When film is rated at an ISO higher than its normal rating, the film is actually being underexposed and then overdevel-

When the subject is side-lit, a reflector can be used to reflect light onto the shadow side. This illuminator by Westcott has two reflecting surfaces, one white, the other gold. These reflectors are available in various sizes and fold into a small package that can be attached to a camera bag.

stops is the maximum film can be pushed with acceptable results.

Be sure to indicate to the photo lab the amount of push or pull. Some films don't respond well to push processing, and it may be necessary for the photographer to experiment and determine which films can be processed with acceptable results.

An increase in granularity and contrast, or both, can occur when some slide films are pushed. Another side effect of push processing these films is a change in color.

Color negative films can also exhibit these side effects. Color shifts in negative films, however, can be corrected when the final prints are made.

The only reliable way to determine if any film responds well to push processing is to test a roll. Some high-speed films must be push processed to achieve their highest ISO rating. Data packaged with the film or published by the manufacturers, available from film suppliers, are the best source of information about these "push" films.

The Outdoors in Color

A long lens and a blind in the right place allowed the photographer to get this portrait of a whitetail buck. Photographs such as this require a lens of 300mm or longer.

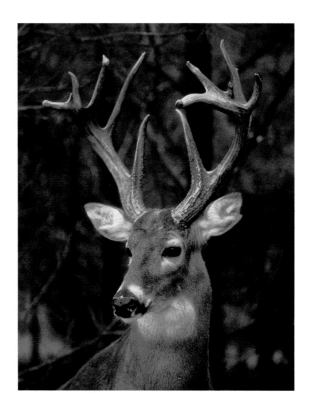

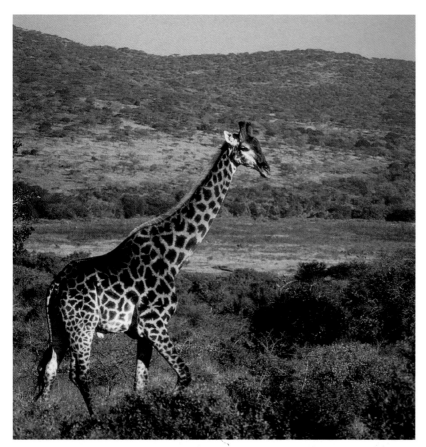

A well-prepared photographer on an African picture safari photographed this giraffe from a vehicle. The camera was in the program mode and provided a correct exposure in the even lighting.

Close-ups of wild flowers such as this trillium can be made with a macro lens or a macro zoom lens. Shallow depth of field rendered the background out of focus, separating the main subject from the background.

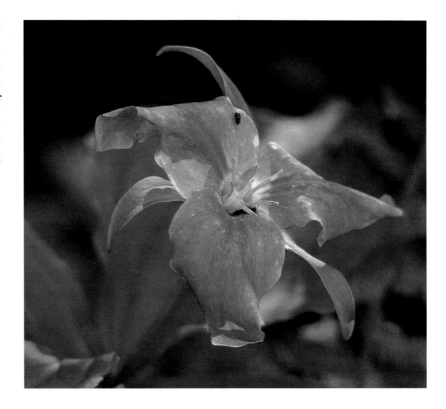

Nearly 700 species of butterflies can be found in North America. These insects are not only beautiful, they are easy to find. Butterflies can be photographed from distances of six to ten feet with a telephoto lens of 100 to 300mm or a comparable zoom lens.

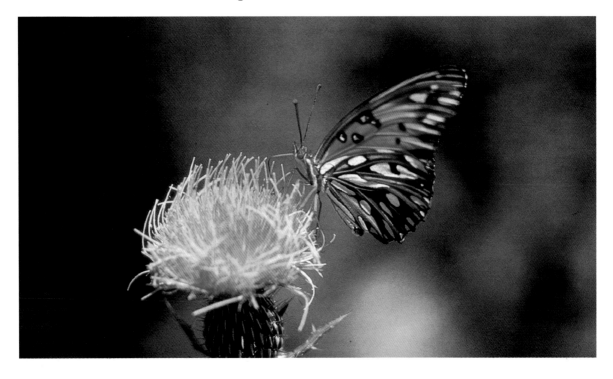

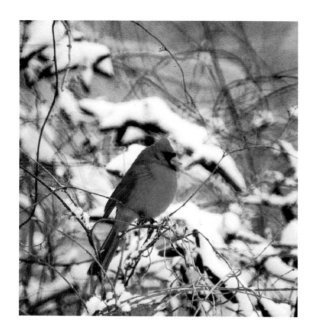

Snow and overcast skies should not deter the serious photographer. This cardinal contrasts beautifully with the snow-covered tree. Careful measurement of the light with an incidence meter resulted in the correct exposure of both the bird and the snowy background. This photograph was taken near a bird feeder.

Patience paid off in this picture of a clutch of house sparrows at a feeder. When the birds came to the feeder the photographer began taking photographs with a camera equipped with a power film advance. This was the best of six photographs taken from a window with a 300mm lens.

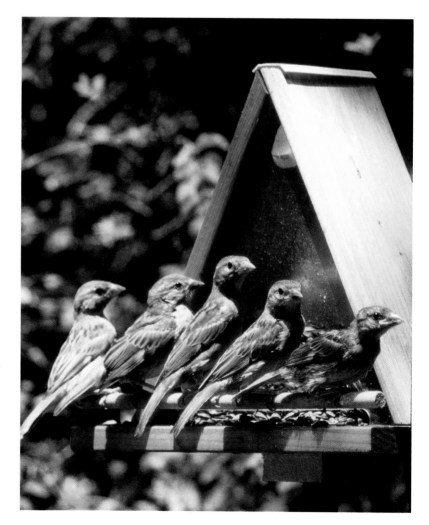

Zoos and wildlife parks are excellent places to get pictures of birds that are difficult to approach in the wild. Careful composition and shallow depth of field can eliminate the caged look of captive animals by softening foreground and background.

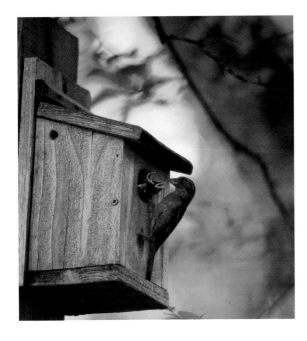

Backyard nature photography can be simple and rewarding. Unlike working in the field, the photographer at home can observe the daily activities of the subjects and choose the best time to take pictures.

One of the best scenic subjects, sunsets can be difficult to meter for correct exposure. A reading off the trees would have overexposed the sky and a reading off the sun would have resulted in an underexposed photograph. The sunny 16 rule applies to photographing sunsets (see Chapter 4).

Pictures are made in the mind and taken with a camera. A good scenic picture can be as simple as this old fence post. The rusted barbed wire on one side and new on the other, lichens forming on the surface and the young evergreen tree all give this subject interest and convey a feeling of the season. Shallow depth of field renders the background completely out of focus.

This mountain trout stream is covered by a canopy of trees with little or no bright sunlight falling on the pool. Even though the photograph was taken on ISO 400 film, the exposure required was ½ second, which rendered the waterfall pleasingly blurred. The camera, with a 28mm wide-angle lens, was mounted on a tripod.

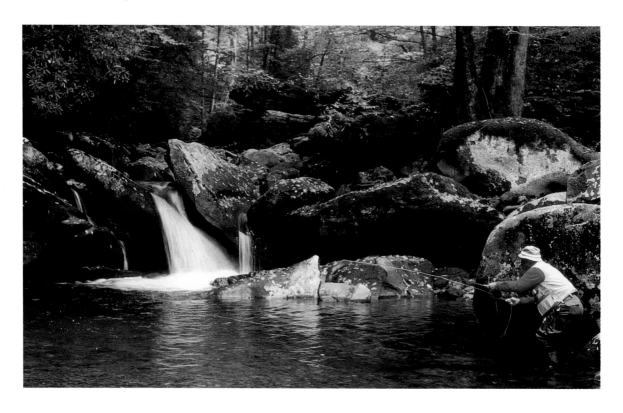

The accouterments of many sports can be used to create beautiful photographs. This fly fishing picture was carefully arranged to create a good composition. The scene was set under a canopy of cypress trees and a gold reflector was used to bounce afternoon sunlight onto the subject. The lens: 28–80mm zoom in about the 75mm position.

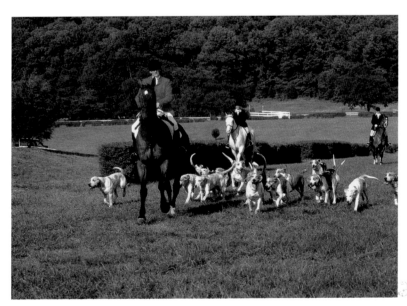

This scene was part of a ceremony during a major steeplechase. The pageantry of any spectator sport can offer as many opportunities for photographs as the actual competition, and should be part of the photographic coverage.

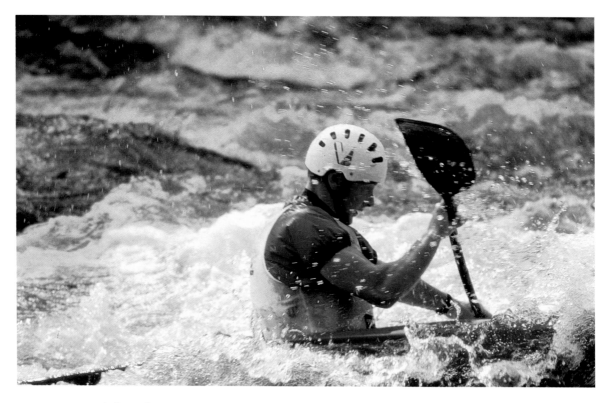

A fast shutter speed of 1/500 of a second stopped the action of the Kayaker and the water. The fast shutter speed, a 300 mm lens and ISO 100 film produced a sharp close-up of a sporting event

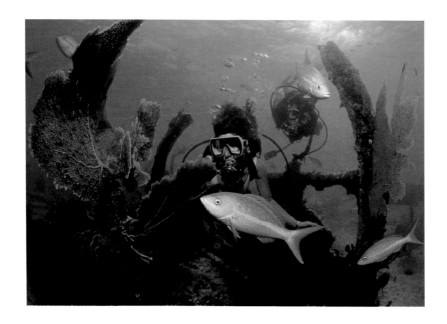

These divers were photographed near the surface in clear water. A flash to the left of the camera provided light for the fish and coral, as well as for the diver's face.

When a reflector fills in the shadow side of the subject, calculating exposure is simpler than when using fill flash. In bright sunlight, with ISO 100 film, the exposure was 1/125 at *f*/16.

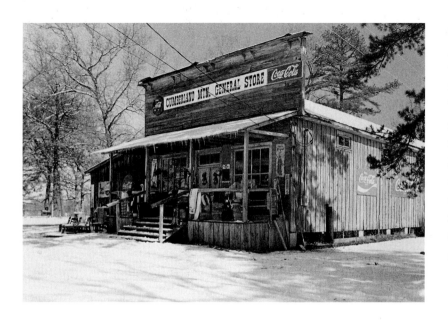

The front of this country store was in the shade with bright sunlight falling on the right side. The camera was in the manual mode and a spot reading was made on the front of the store. Snow on the ground in front of the store served as a reflector, adding soft light to the otherwise dark store front.

Stops and *f*/Stops

A common term used in photography is "stop." This is not the same as *f*/stop. A stop indicates a unit of measure that either doubles or halves a value. For instance, the difference between 1/60 second and 1/125 second is one stop; the difference between ISO 200 and ISO 400 is one stop; and the difference between *f*/2.8 and *f*/5.6 is one stop. The difference between *f*/4 and *f*/5.6 is approximately one half-stop. An *f*/stop is one increment of measure on the lens.

Half-Stops

f/1.4 1.8 2.8 3.5 4 5.6 8 11 16 22 32 64

Full Stops

f/1.4 2.8 5.6 11 22 45

It is preferable when push or pull processing to be able to tell the lab how much to push or pull in stops. If you expose ISO 100 film at ISO 400 the push is two stops. Otherwise tell the lab at what ISO you exposed the film. They will know how much push or pull is needed.

Actual ISO	25	50	64	100	200	400
Push/stops			New ISO			
1	50	100	125	200	400	800
2	100	200	250	400	800	1600
3	200	400	500	800	1600	3200

The following *f*/stop shutter-speed combinations will deliver the same amount of light to the film:

1*	*f*/32
1/2*	*f*/22
1/4*	*f*/16
1/8*	*f*/11
1/15*	*f*/8
1/30*	*f*/5.6
1/60**	*f*/4
1/125††	*f*/2.8
1/250	*f*/2
1/500	*f*/1.4

* Tripod is necessary for critical sharpness

** Tripod is recommended

†† Tripod is recommended for lenses having a focal length longer than 100mm

5

Composition

Composition is simply the arrangement of elements in a photograph to achieve balance and eye appeal. The basis of composition in photography is the rule of thirds. A photograph can be divided into three equal parts, vertically and horizontally, creating an imaginary grid of nine panels. Place the main subject off center into one area of grids rather than in the center. In a landscape photograph the three parts would be foreground, mid-ground and background. These imaginary vertical and horizontal lines are the basis for the rule of thirds. In addition to the nine panels in the grid, imagine a diagonal line from either top corner of the photograph to the opposite lower corner as another guide for composing a scene off center. Though it is a good guideline, the rule of thirds is not absolute.

Light, shadows and texture also contribute to composition. Shadows can frame a subject or direct the viewer's eye to the main subject. The direction of light can enhance a composition by providing shape and form to the scene. Texture as a composition element may be the bark of a tree or patterns in a field of grass. A good scenic photograph can have all of these elements in addition to the geometry of the rule of thirds.

A painter can arrange the elements of his picture according to his taste. A still-life photographer has the same advantage. An outdoor photographer can ask people to move, but otherwise he has to move his camera.

The subject usually dictates its own format. Tall trees or structures would call for a vertical format in most cases. A seascape or a desert might call for a horizontal format. In either case the opposite could be true. There are times, as when shooting a magazine cover, when a vertical format is required. It is up to you, the photographer, to use your skill and imag-

Cameras are designed so they are comfortable to hold vertically or horizontally. The photographer (top left) is using her knee to steady the camera in the horizontal position.

In the same position the photographer (top right) holds the camera in the vertical position. Not all scenes can be photographed holding the camera by hand. Long exposures as well as pictures taken with long-focal-length lenses require a tripod or other device to hold the camera steady.

In a standing position the photographer (left) is resting the camera on the heel of her hand. This position is comfortable and allows her to reach the lens controls with one hand and the shutter button with the other. In this position she can rest her elbow on her torso.

ination to create the photograph.

Try to imagine the final image. Not on a slide or in a viewfinder, but in its final form. Imagine the finished, matted and framed photograph hanging on a wall. The ability to visualize the photograph is very important, natural to some photographers and achieved by others only after much practice. The ability to compose a picture should become instinctive. News and documentary photographers have to work quickly, often taking pictures at a moment's notice, yet they often produce images that are well composed.

Choose a format and a lens before you look through the camera. You can do this by making a viewing mask with a window cut out of a piece of 8x10 black mounting board. The window opening should measure 2 by 3 inches. Use this to frame a scene before you pick up the camera.

One of the most common mistakes photographers make in composition is failing to watch the background. A tree, pole or any object directly behind a person's head will ruin an otherwise good outdoor portrait. A cluttered background will distract from an outdoor portrait. While it is sometimes desirable to have an identifiable background, an outdoor portrait will be more flattering to the subject if the background is minimal, either out of focus, or very simple. Objects such as power lines, debris or unidentifiable shapes that distract from the subject must be eliminated by changing camera angle, distance from the subject, or by using a different lens.

A tangent is created when two or more objects touch visually side to side. This often flattens a photograph. To create visual depth, objects must be in the front, the middle or the background of a photo and should either overlap one another or be separated. The suggestion of distance can be enhanced by placing the main sub-

This photographer is using a viewing window to find a scene. By placing the frame the correct distance from her eye, she can compose the scene and determine the best lens to use before setting up the camera.

This scene can be divided into three main sections, and nothing is dead center. The main element in this picture is the waterfall, which has been placed to the right of the frame. A diagonal is formed by the bushes in the foreground. The waterline at the bottom of the waterfall is one third of the way from the bottom of the frame and establishes a middle ground. The dark cliffs to the left balance the light waterfall. The bush to the left breaks up the dark cliff and adds scale and interest. The tree branch on the right lends scale and interest and helps to place the viewer in the scene. The falling water on the left is moving off the frame while the water on the right is almost vertical. The whole composition is in balance.

A horizontal composition with a strong foreground. The main point of interest, the canoes, is slightly left of center. The waterline serves as a horizon separating the foreground from the background. The foreground helps to frame the picture and lend scale and interest. The trees on the left and right form a V shape over the river as if pointing to the canoes. The old bridge adds an interesting element to the scene and completes the frame around the canoes.

ject on a different plane. If the main subject is near the lower third of the frame, the scene will have a feeling of closeness. If the main subject is placed near the upper third, distance is suggested.

When the main subject is surrounded by clutter or when the surroundings fail to contribute to the scene, crop tight on the subject. Do this by moving close to the subject, changing lenses or both. A busy photograph can be improved by filling the frame with the subject. When a scene can't be cropped in the field it can be done in the darkroom or when the slide is duplicated.

See photos on following pages.

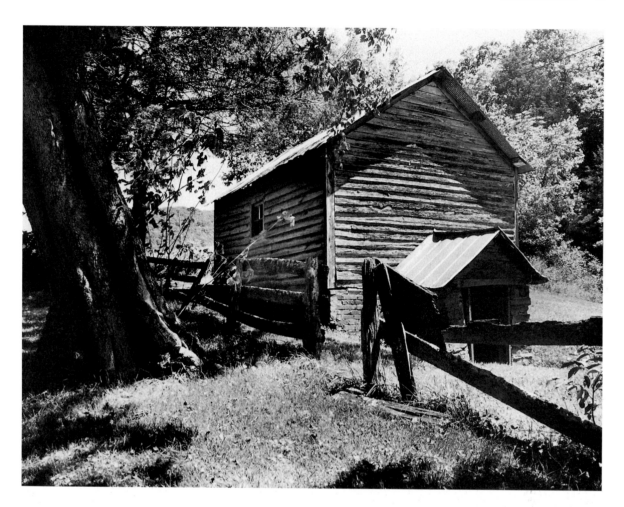

Some scenes can be composed as either a vertical or horizontal, creating two different moods. This old spring house is the main element in the vertical composition (left), but the scene could suggest that it's located alongside a road. By moving away and photographing the scene as a horizontal (above), the picture takes on a different meaning. Both photographs were taken with a 24mm (wide-angle) lens.

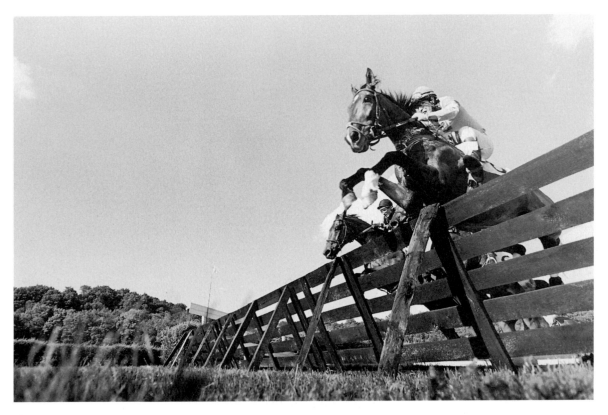

This photograph was taken by remote control, with the camera placed at the bottom of a spectator fence. When the horses started over the fence, the motor drive was activated. Out of ten exposures, this one had the best action and composition.

Cropping tight on the action and enlarging the area creates a more dramatic photograph. The fence at the lower part of the frame provides a long angle to the left. The horses and riders are moving upward and to the left into the open sky.

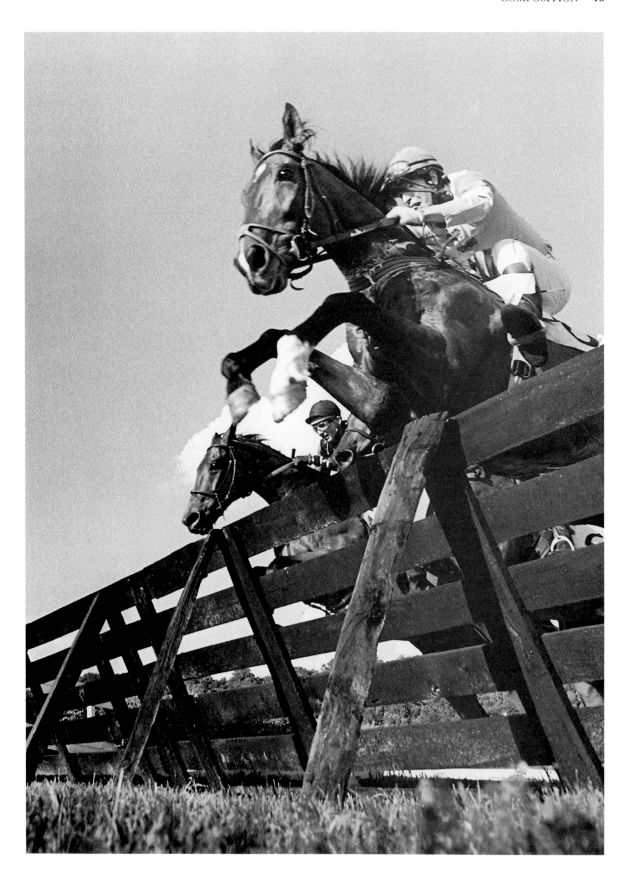

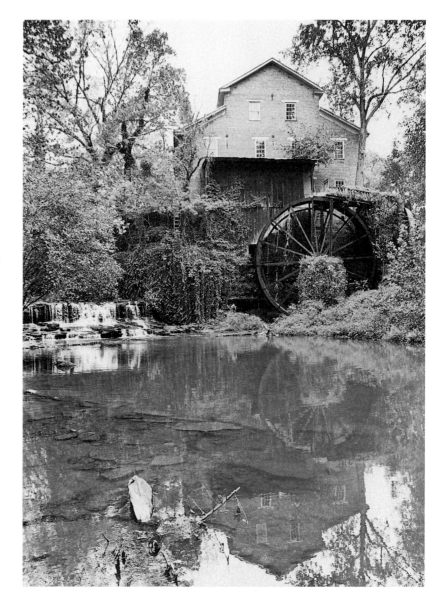

At first glance this appears to be a good composition. Upon closer study, however, a rock and debris can be seen in the lower left foreground.

Changing the camera angle slightly to the right has eliminated the unsightly clutter in the water. The main subject of this scene, the mill house, is slightly off center and the building's reflection balances the total picture.

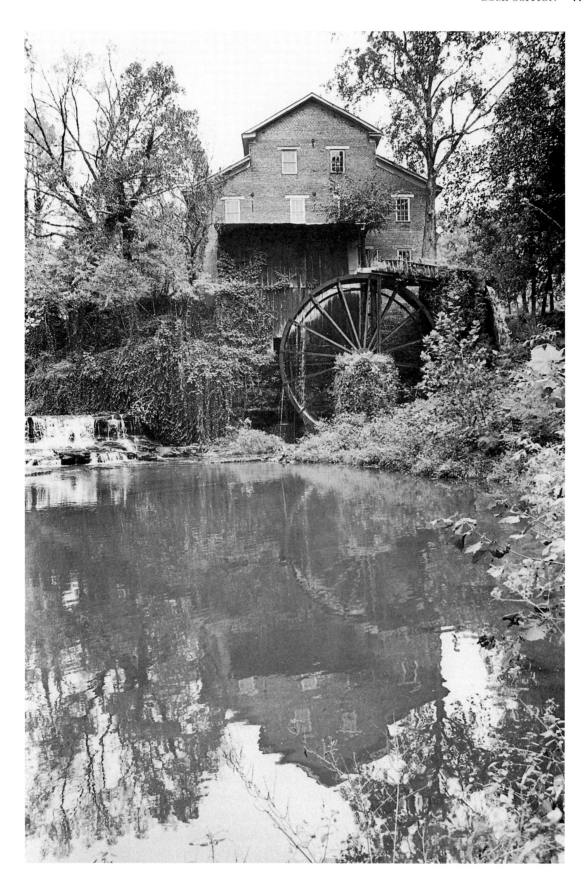

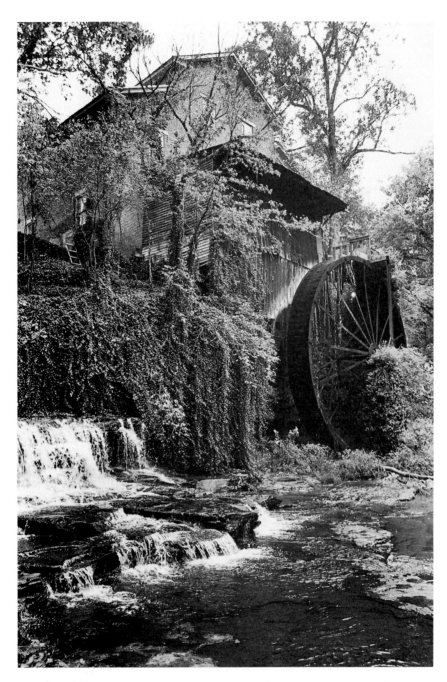

Another view of the same subject produces a more dramatic photograph. We now can see two sides of the building, and the angles of the roof are more interesting. Imagine a line drawn from the water wheel's axle to the waterfall and another line drawn from the axle to the small ladder by the building. These two imaginary lines help to direct the viewer's attention to the wheel. A slow shutter speed would have improved the flowing water; it would have also blurred the water wheel. This is a choice the photographer had to make.

In this simple picture, light and shadow, as well as interesting angles, create a striking composition.

Textures, shapes and patterns in the bark lend interest to this photograph of a tree.

6

Flash Photography

There are two ways to shoot flash photographs: full flash and fill flash. Full flash is when the flash is the main source of light; fill flash is when the flash supplements natural light to illuminate, but not overpower, shadows. It may be necessary to use flash when there is not enough natural light to get the picture with slow film, when the main subject is in shadows, or when the main subject is in bright sunlight and the resulting shadows are dark and without detail.

Fill flash seems to be the most difficult to understand, and a lot of otherwise good photographs have been spoiled by its improper use. The flash should not be as bright as the natural light. A good starting point is to consider the amount of fill needed to be half that of the natural light. If the natural light exposure is $f/16$, the exposure indicated for the flash should be $f/8$. Therefore, expose the film at $f/16$ so

the natural light remains the principle source of illumination. Many of the newer dedicated flash systems have a fill-flash setting that provides correct fill-flash exposure when the camera is in the program mode. Additionally, most modern cameras with built-in flash have an automatic fill-flash mode. These are only suggested starting points and hypothetical exposures. The results from various exposures and metering systems differ. Test your system and become familiar with its operation. Once a formula is established you will be able to get predictable and consistently good photographs.

For full flash, set the $f/$stop for the required flash exposure, which should be a higher number than the natural light exposure. If the natural light requires $f/11$, the flash should call for $f/22$. The flash becomes the main source of light when it is brighter than the natural light.

HARDWARE

There are several kinds of electronic flash devices in popular use. The most common ones are the small battery-powered units that attach to the top of the camera. These compact flashes can have either a built-in automatic exposure circuit, or they may be part of a total electronic exposure system called "dedicated." A dedicated flash reads flash through the lens as a part of the camera's electronic exposure system. Some

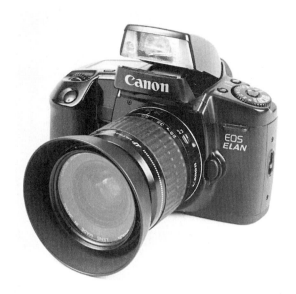

This pop-up flash is built into the camera. These little flashes are designed for work at short distances. When the flash is on the camera and close to the lens, a condition known as "red eye" can occur in pictures of people. The light from the flash travels through the pupil of the subject's eyes and illuminates the red retina. A simple solution is to have the subject look a little to one side of the flash.

Vivitar electronic flash mounted on a Stoboframe gets the flash away from the camera and over the lens to help eliminate background shadows. This bracket can also swing out from the camera to create more pleasing side light.

cameras have built-in electronic flashes.

Larger, handle-mount electronic flashes are detached from the camera and mounted on a bracket from which they can be removed for off-camera lighting. These units are usually powered by external battery packs. The most powerful electronic flashes are those used in studios. These units have two lamps, one of which is the modeling light used to see the lighting, and the other the flash lamp used to make the exposure. Some studio flash systems are not only powerful but compact enough to use in the outdoors.

Here powerful electronic flash heads that connect to a power pak are set up to photograph small specimens in a glass case. Side lighting with two heads, or two photofloods, eliminates glare.

A small electronic flash can also work well with a specimen case. The white card on the left will reflect light onto the subject's shadowed side. The inside back of the glass case should be lined with a nonreflecting material such as velvet, felt or matte finish paper.

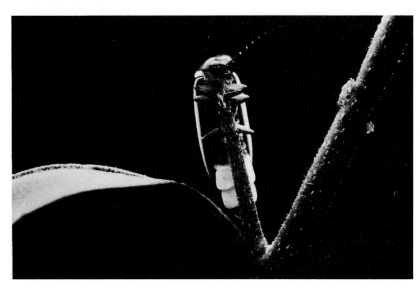

This firefly was photographed in the specimen case with the two-light system. The background is black flannel.

CALCULATING EXPOSURE

Determining correct exposure for flash can be done in a number of ways: automatically with the built-in light-sensing system of the flash; manually with the distance scale of the flash; with guide numbers; or with a flash meter.

Automatic flash units allow you to take pictures over a range of distances at the same f/stop. Located on the flash is a distance scale and corresponding ISO scale. Set the ISO and the scale will indicate the f/stop to use within a working distance of the flash, which is indicated on the instruction sheet. The electronic sensor of the flash measures light reflected by the subject and automatically controls the flash duration to provide correct exposure. Flash duration of some units can range from 1/800 second to 1/20,000 second.

Manual exposure is calculated with a distance scale or by using guide numbers. The distance scale will be opposite an adjustable ISO scale. Set the ISO to the indicator mark and the scale will indicate correct f/stops for each of the distances that are marked.

Guide numbers that are used to calculate flash are usually included in the operating instructions for electronic flashes. Each ISO has a guide number which, when divided by the distance from the flash to the subject, will provide an accurate f/stop. As an example, if the guide number is 120 for ISO 100 at full power, and the flash is placed 10 feet from the subject, the calculated f/stop is f/12. Set

the lens to a point halfway between f/11 and f/16, which is f/11.5 (F=D/GN).

The distance from the flash to the subject can also be calculated to correspond to a selected f/stop. If f/16 is chosen, divide the guide number by the f number. The result is the correct distance of flash to subject. A guide number of 120 divided by f/16 indicates a distance of 7 to 12 feet (D=GN/F).

When a flash is used off-camera, exposure is calculated for the distance between the flash and subject. The distance from the camera to the subject is not a factor. One way to determine the distance is to use the camera as a measuring instrument. Place the camera at the position of the flash and focus on the subject or the point at which you expect it to be. The focusing scale on the camera will show the distance. The best way to be certain is to use a measuring tape.

The most accurate way of calculating flash exposure is with a flash meter. Some flash meters read both reflected and incidence light, and many will read a combination of flash and ambient light (see section on exposure, Chapter 4). To use a flash meter, set the ISO of the film being used and set the shutter speed. If it is a reflective meter, point the meter at the subject, or at the camera if it is an incidence meter. Attach the connecting cord from the meter to the flash, trigger the flash and the meter will indicate the correct f/stop. The light falling on the subject can be increased or decreased by moving the flash closer or farther from the subject.

When a flash must be used outdoors, it should be removed from the camera. Off-camera lighting is more pleasing and natural looking.

The brief burst of light from a flash must synchronize with the camera shutter. On most cameras the synchronous (sync) speed is usually 1/60 or 1/125 second. The sync speed can be higher on some cameras, and if so, will be pointed out in the camera's instruction book. Any shutter speed slower than the indicated sync speed will synchronize with electronic flash.

The sync speed is also referred to as X sync. Older cameras may have two connections for flash cords, one marked X for electronic flash and one marked M for flash bulbs. Medium-format shutters may also

have a selector for X and M sync. Always use the X connection for electronic flash.

Action photography with a mix of natural light and flash at slow shutter speeds can result in a ghost image that looks like a dark shadow around the moving subject. This is actually double exposure. The camera records a moving subject at slow shutter speed and the slow duration of the flash records the frozen action of the subject before the shutter closes.

To eliminate the ghost image, adjust the flash exposure so that it will be brighter than the natural light and use the highest

This outdoor portrait was made at sunset using one electronic flash held off camera. The exposure was balanced to make the subject slightly brighter than the background. This exposure rendered the background a deep, warm orange in the original color photograph.

shutter speed possible without being out of sync. Some cameras have a high enough sync speed to get rid of the ghost image. Most medium-format cameras have a different kind of shutter than 35mm cameras which will synchronize at speeds up to 1/500 second. The best way to keep from making ghost images is to avoid using flash on fast-moving subjects.

Manual Exposure for an Electronic Flash Rated at 2250 BCPS

Distance	5	10	15	20	30	40	50	60
ISO	f	f	f	f	f	f	f	f
25	11	5.6	4	2.8				
50	16	8	5.6	4	2.8	2	1.4	
100	22	11	8	5.6	4	2.8	2	1.4
200	32	16	11	8	5.6	4	2.8	2
400	45	22	16	11	8	5.6	4	2.8

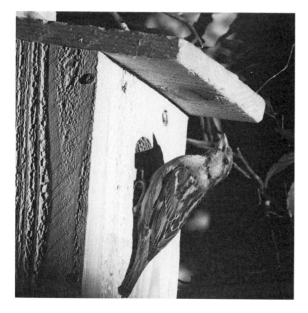

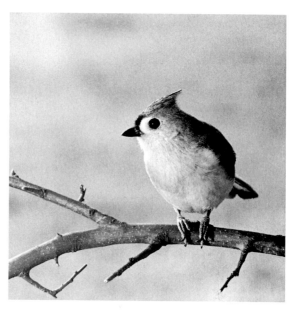

This photograph was made on a bright day with the bird in shade. Instead of flash, a mirror of about 12 x 24 inches was placed on the ground and reflected full sunlight onto the subject.

This tufted titmouse was photographed at a feeder from an open window. The flash was on a light stand near the limb. The scene was backlighted, and the flash provided front light. Exposure was determined with a flash meter.

Built-in flash fill on a small camera opened up the shadows in this picture taken when the light was directly overhead, creating hard shadows on the subject. The flash fill opened up the shadows but did not overpower the natural light.

7

Accessories

Of the countless photographic accessories available, devices designed to steady the camera are the most important. The best-recognized and most widely used are tripods. These can range in size from small folding models less than a dozen inches in height to deluxe versions with telescoping and adjustable legs that can attain heights of up to 6 feet, ball-type heads to lock the camera into any position desired, and bubble-type levels. In between are myriad variations to suit any need, the most popular of which are the light, compact models suitable for attaching to the camera bag on D rings. Modern materials such as graphite have greatly reduced their weight while still providing a steady camera platform.

Less known but a highly suitable alternative to a tripod is the monopod. As the name implies, this apparatus consists of a single leg which can be telescoped to whatever height is needed. Some have a folding bracket at the base on which a foot can be placed for additional stability. Some monopods are designed so they can also be used by hikers as a walking staff.

C-type clamps that can be attached to limbs, wooden fences, the edges of tables, window sills, etc., are also popular devices. These are used mostly when taking photographs with the camera's self-timer, when very slow shutter speeds and a cable or air release are necessary, or in places where a tripod isn't practical.

When taking pictures from a vehicle, a window mount can greatly improve your chances of getting good results, especially when using long-focal-length lenses. This device provides solid support for shooting at slow shutter speeds and is a particularly valuable accessory for individuals

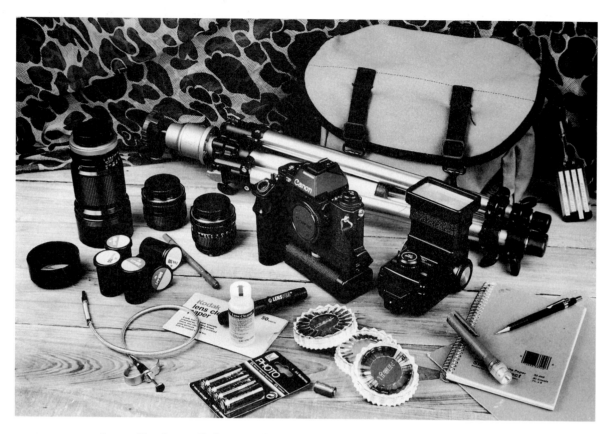

A good basic outfit for travel and outdoor photography includes: camera with motor drive, electronic flash, lightweight tripod, wide-angle lens, normal lens, long-focal-length lens, cable release, filters, lens-cleaning kit, spare batteries, pocket flashlight, notebook and pencil, gray card, film and a felt-tip pen to label film cassettes. All but the tripod will fit in the canvas bag.

who are handicapped or otherwise unable to go afield. It is a real winner in inclement weather.

While not often seen, gunstock-type camera mounts can be especially useful when photographing action. When brought to the shoulder like a gun, they provide good support, allowing the photographer to swing the camera smoothly and follow a moving subject. Early models were made of wood and were actually modified gunstocks. Modern versions have wire frames and are lighter and less cumbersome.

Sandbags are very useful for stabilizing long-focal-length lenses when taking photographs from a car hood or any other solid platform, but because of their weight, they are not practical for carrying into the field. It is possible, though, to take an empty bag along and fill it with sand or dirt at the site where you will be shooting pictures.

Tripods come in all sizes and price ranges. Seen here are lightweight field tripods, a monopod, a pocket tripod as well as heavy-duty ones used for large-format cameras and cameras fitted with large telephoto lenses.

A good tripod is essential for getting sharp images with telephoto lenses, or with any lens when a slow shutter speed is required. The photographer is using a 400mm lens and camera secured on a medium-sized tripod.

A monopod is useful when shooting sports with long lenses or when moderate exposure is called for. Often a monopod can replace a tripod.

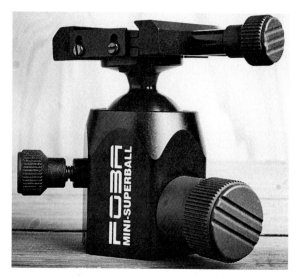

A Foba Mini Superball head will replace the head on most heavy-duty tripods and is the choice of many outdoor photographers who work with big, heavy lenses. A ball head gives the photographer unlimited control of camera angle.

This photographer is using a Bushnell lightweight tripod that folds to less than 12 inches in length. These featherweights can be carried in a camera bag or vest pocket.

Finally, a forked stick or a tree crotch can also be employed to steady a camera when standard accessories aren't available.

CAMERA BAGS AND CASES

The choice between soft camera bags and hard cases is governed mainly by the conditions under which the photographer expects to work. Soft cases are the most popular, primarily because they are more versatile and allow greater flexibility in storing gear. The better ones are extremely well engineered and afford maximum protection against impact and weather. Too, soft cases come in a broad variety of sizes, and many photographers have both small and large ones to accommodate whatever equipment is needed for different projects.

Most hard cases are shaped like suitcases and provide very good protection under ordinary circumstances. They are well-padded with foam, are dustproof, and suitable for general use. However, the best choice for the outdoor photographer are the high-impact plastic cases which are airtight and waterproof. What's more, they float!

Worth mentioning are the plastic utility bags that are inflatable and waterproof, which are ideal for carrying a small

amount of camera equipment on float trips or other aquatic ventures where it can be in jeopardy.

Photographers have almost unlimited choices of bags and cases in which to pack camera gear. Shown here are (from left): Cordura canvas bag by Domke, preferred by many news photographers; photographer's backpack by Canon; Pelican model 1200 waterproof hard case with foam insert; Pelican 1520 waterproof hard case with moveable dividers; optional canvas camera bag that fits into the Pelican 1520 case. The 1520 case is also available with foam inserts.

CLEANING ACCESSORIES

Photographic equipment used in the outdoors is exposed to the elements, which means that the photographer has to be vigilant and keep a close eye on things that will either impair an image or cause camera malfunction. Moisture in the form of fog, spray or rain can cloud a lens. Normally, this can be easily removed, but in the case of salt water, a film is created on the lens that is more difficult to remove. Also, wind-blown salt spray may contain tiny particles of sand that can damage a lens and invade the camera's mechanism.

Dust and sand are always present, and these can be easily removed with a soft lens

This Fieldline pack has a water bottle and an extra pocket that can accommodate a lens. It's large enough to carry film, filters and lens-cleaning kit with room for a small first-aid kit and lightweight rain jacket. A camera with zoom lens and a monopod rounds out a compact outfit good for a day trip.

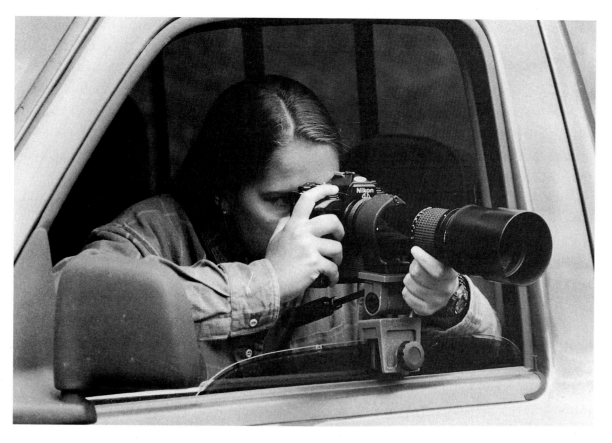

A window mount steadies the camera and allows the photographer to work from inside a vehicle.

brush. The best kind are ones with a squeeze bulb attached that blows away excess material before the brush is applied. Thorough cleaning often requires lens cleaning fluid and lens cleaning paper, and it is wise to do this before and after every photo session. Warning: Cans containing compressed air sold by camera stores should not be used for cleaning interior parts when the lens is removed. This high-pressure air can damage the shutter. It is only suitable for blowing debris from the lens or the exterior of the camera.

OTHER ACCESSORIES

Collapsible Mylar reflectors have become extremely popular accessories for outdoor photographers. They are superior to flash units because they rely on natural light. Photos are therefore more authentic in quality. Mylar discs are white on one side and gold-tinted on the other to match the kinds of light present in normal morning and afternoon conditions. These discs vary in diameter from 2 to 6 feet, but their advantage is that they fold into a much

smaller size and fit into a carrying pouch that can be attached to a camera bag.

If you have rewound a roll of film into the cassette when only a portion of the exposures have been made, the remaining images are often wasted. This doesn't have to happen, because there is a small, inexpensive device that can be inserted into the cassette opening to retrieve the film tab. On most cameras it's possible to put the cassette back in later and advance the film beyond the last image taken. Before rewinding the film initially, the number on the counter should be noted and placed with the cassette for reference.

Even though your camera has a low battery indicator, it's a good idea to have a battery tester. Most cameras rely on several batteries, but getting a negative reading doesn't mean all of them are bad. Sometimes only a single battery has lost power and the replacement of the entire set isn't necessary. A tester can determine this in seconds and save discarding other batteries that may have plenty of power left. There are compact units available that fit easily into a small camera bag pocket.

A small, compact flashlight should be considered a must. It will serve many purposes, from traveling to or from photo locations in darkness to reading f/stops, shutter speeds and film counter numbers in low light. It can also illuminate a subject in order to determine distance when taking flash pictures at night.

When carrying a canvas or Cordura camera bag, include a large plastic trash bag with a tie. This is useful for protecting your equipment in a sudden downpour or in a boat when it can be doused by spray. It can also prevent dust from getting to equipment when the bag is stored in the trunk or rear of a vehicle traveling off paved roads.

8

Wildlife

Capturing images of birds and animals in the wild is one of the most exciting and satisfying forms of outdoor photography. At the same time, it is one of the most challenging, because to be consistently successful the photographer must possess all of the skills of a dedicated hunter or woodsman. Most wild creatures are extremely shy and cautious, and getting within camera range requires stealth, a knowledge of the subject's habits and, above all, patience. True, chance encounters with wildlife may offer rare opportunities for good photographs, but ordinarily such results are preceded by a considerable amount of planning and effort.

The opportunities are endless. Small animals such as squirrels and rabbits are found almost everywhere, as are waterfowl and birds of prey. Whitetail deer are numerous throughout a great part of the United States, and are favorite subjects of amateur

and professional photographers. Pictures of deer appear frequently on magazine covers, calendars and in advertisements.

There are four major species of wild turkeys in the United States, and these majestic birds are found in virtually every state. They're great photographic subjects but are also one of the most wily and elusive of all wildlife subjects. Spring is the best time to photograph wild turkeys, since it is the mating season and the gobblers are seeking to attract a harem of hens. Calling the birds in requires considerable skill, but it brings better results than stalking.

It is well to remember that extreme caution must be exercised in photographing some wildlife subjects. For instance, bears, either black or grizzly, are immensely powerful and unpredictable, and attacks on humans often deadly. Some attacks are unprovoked, but many occur when a photographer is attempting to take photos of a

mother bear and cubs. No picture is worth risking your life or the lives of those around you. Don't work alone in bear country, and when moving along trails, sing or make plenty of noise. This will prevent surprising a bear. When you reach a safe place from which to photograph, remain very quiet. Remember, always, that the cartoons that depict bears as warm, friendly and cuddly creatures are absolutely false. To think otherwise is folly and an invitation to disaster.

Other large animals, particularly bull moose and bull elk, can also pose danger,

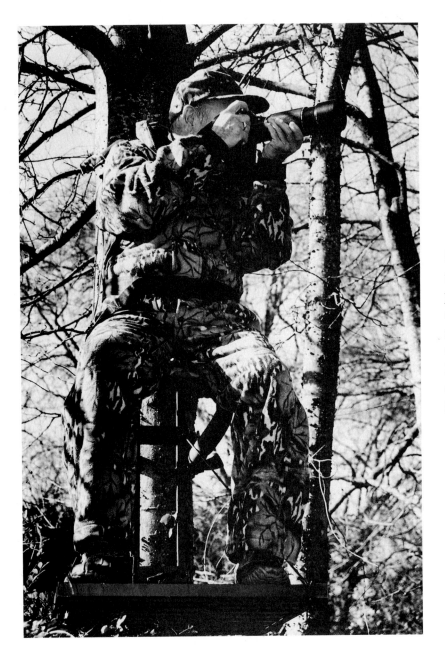

Stationed on a portable tree stand, this photographer is well hidden from animals on the ground and has a clear view of wildlife. He is wearing Browning's Hydro-Fleece camouflage clothing, which is rainproof and quiet.

particularly during the rutting season when they are revved up on hormones. For that matter, buck deer should also be given a wide berth at such times.

The real challenge in getting good wildlife photos is finding a strategic position in which to conceal yourself and wait. This requires exploring the animal's territory, learning its travel routes, and where and when it feeds. The spot you select must be properly lighted and downwind of approaching animals. You must have natural cover or a portable blind or tree stand to provide concealment. There are

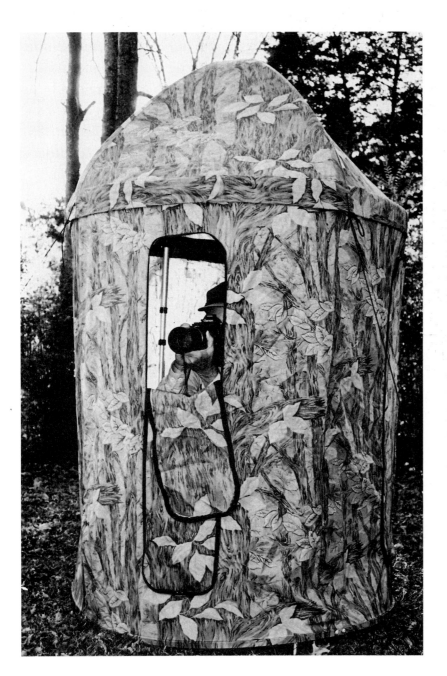

This portable blind from BBK folds into a compact backpack that weighs 12 pounds. When assembled it's roomy enough for the photographer and a large tripod. An effective way to use the blind is to scout a likely area, assemble the blind, leave it in place overnight and arrive before daylight. If possible, leave the blind in place for a few days before using it to let wildlife become accustomed to its presence.

numerous light, portable ground blinds on the market which can be erected in minutes in the field. The simplest method of concealment is simply to wrap yourself in a few yards of camouflage netting.

The advantage of a tree stand is that it is elevated and allows an extensive view of the surroundings. Several kinds of tree stands are available. When shooting from a tree stand, always use a safety belt.

There are a number of commercial blinds on the market, most of which are used by hunters, but there is also a model

Camouflage netting is lightweight and can be folded into a day pack or tied to a camera bag. The photographer is well concealed in this simple blind.

designed specifically for photographers that is light and can be carried in a backpack. The company which manufactures this blind now has a model designed to be mounted in a tree, providing a snug, roomy photo platform. Some smaller tree stands also feature camouflaged fabric screens to better conceal the photographer.

Sometimes it isn't possible to place a blind at a location suitably close to where the subject will be, in which case remote photography can be used very effectively.

Hunting deer with a camera can be as difficult as hunting them with gun or bow, and the photographer should take advantage of the tactics and techniques employed by sportsmen. It is important to wear camouflage clothing, and in some instances substances to mask or nullify human odor. Photographers should scout the area and look for signs of deer activity in the form of droppings, tree rubs and scrapes. Buck deer rub trees to rid their antlers of velvet, and in doing so remove bark. Scrapes are bare places on the ground caused by a buck pawing the earth. These are sure signs that there are deer in the area. The best time of the year to photograph deer is when they are being hunted, so caution must be exercised when moving about in the woods. Comply with laws regarding the wearing of blaze orange; in most places it is illegal to be without it.

Wildlife photographers rely heavily on telephoto lenses and sturdy tripods, so the equipment taken into the field often amounts to a considerable load. If it is pared down to a minimum, a good photog-

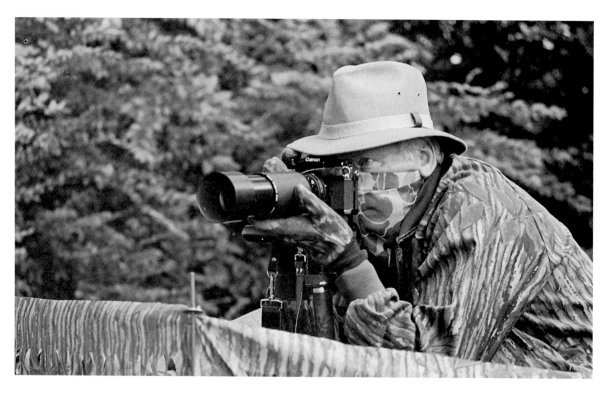

Portable blinds made of camouflage fabric and thin metal rods can be erected quickly and conceal a photographer from wildlife.

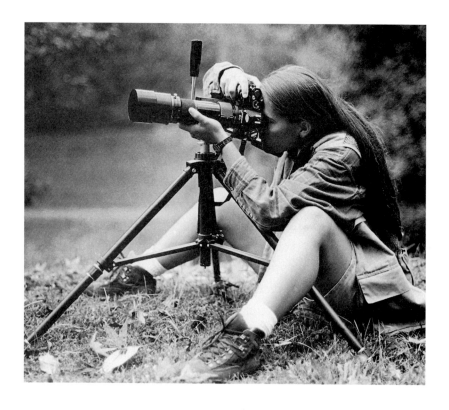

Some wildlife subjects can be photographed without the use of camouflage by sitting very still on the ground and using a long lens. This technique works well in parks where animals such as squirrels are accustomed to people.

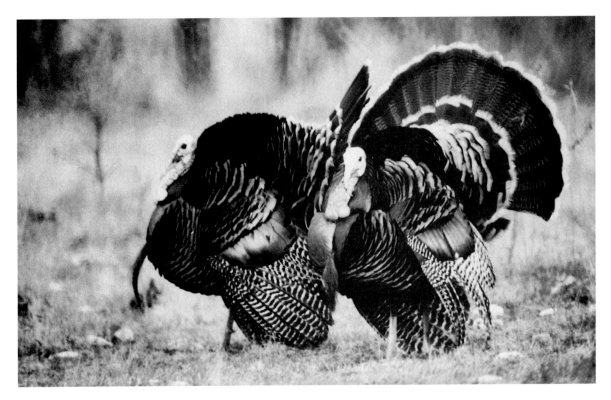

**Wild turkeys are among the most difficult of animals to photograph.
Good camouflage and stealth are required to get pictures like this.**

rapher's vest will be sufficient, but at other times a full-size backpack is necessary.

OTHER PHOTO OPPORTUNITIES

Many, if not most, wildlife photographs are taken at parks, wildlife refuges and other places where the animals are protected and have little fear of human beings. Often they will approach photographers, especially if some tidbit is offered as an incentive. This makes it easy to get good close-ups, and even a point-and-shoot camera with a zoom lens will produce good results.

In some foreign countries, particularly Africa, there are outfitters that specialize in photographic safaris. In Africa, clients are taken into no-hunting areas where they can take pictures of a great many kinds of wildlife, including some of the continent's largest and most dangerous species, from the safety of a vehicle. Many of these places have small and medium-sized animals that congregate in the immediate vicinity of the camp and can be actually photographed from platforms or porches erected for this purpose.

African photographic safaris can be richly rewarding, mainly because of the enormous variety of wildlife photographs that can be collected on one trip, as well as

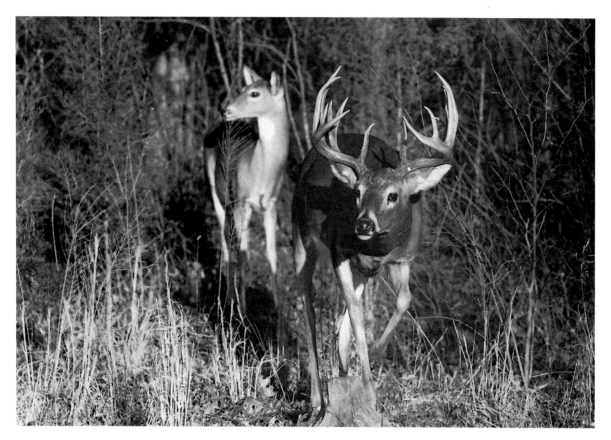

Winter is best time for photographing whitetail deer in most parts of the country. These bucks are sporting matured antlers in the mating season. In late winter it's not unusual to photograph a buck and a doe together.

This whitetail buck, his antlers in summer velvet, was photographed from a ground-level blind. Deer shed their antlers in the spring and grow a new set each year.

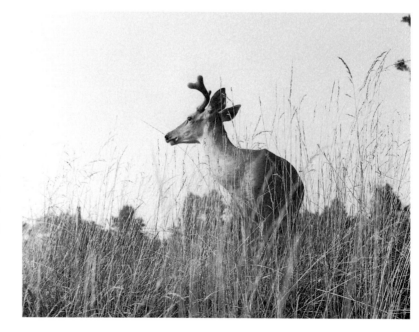

images of birds, flowers, native lifestyles and striking scenery. Those properly equipped can make rare photos of constellations in the night sky of the Southern Hemisphere.

NIGHT PHOTOGRAPHY

The fact that some animals are primarily nocturnal in their habits doesn't prevent you from getting photographs of them. Special setups involving remote cameras, flash units and electronic shutter-tripping devices make it possible to capture images of animals during the night. In such cases the photographer doesn't even have to be present. The entire operation is automatic.

What's necessary initially is to determine where the animal is going to appear, which is usually along a game trail or other established route of travel. The camera and flash unit are then put in place, the f/stop and shutter speed set, and the electronic unit positioned. Most of these units emit a small beam of light which, when interrupted, trips the camera shutter. Earlier models accomplished this with a fine thread stretched across the trail. The advantage of an electronic unit and a camera with an automatic film advance is that a number of images can be captured over a period of time, and sometimes more than one animal's portrait emerges when the film is developed.

FLOAT PHOTOGRAPHY

An especially useful technique in photographing wildlife is to float down rivers and streams in a small craft. This tech-

This photographer is concealed and mobile using a Tote-N-Float inflatable boat and camouflage. You can move about quietly in a stream or pond and photograph many species of wildlife.

Animals such as this bullfrog can be photographed from a boat. Animals are somewhat more tolerant of people in boats than on foot. Many species of birds are also found near or on water.

nique offers particular advantages, one of the most important being that it is silent and permits the photographer to get quite close to the subject without being detected. Also, it often provides access to areas which can't be reached otherwise. Even though you may have one particular photograph in mind, there's no way to predict what other subjects might be encountered.

On a trip down a waterway you may see everything from chipmunks to deer in the way of wildlife.

Canoes and kayaks are useful for such ventures, but on smaller waters, inflatable craft are more satisfactory. Some of these are little more than inflated tubes in which the occupant sits and propels himself with swim fins.

9

Nature Photography

Nature offers a wealth of photographic opportunities the year-round, and one doesn't have to look far in order to find a variety of appealing and fascinating subject material. Almost any outdoor setting offers an abundance of possibilities, and while some of the best places are far from populated areas, living in a suburban or even an urban area need not limit your choice of subjects. Your own backyard offers a host of opportunities.

Birds and flowers are probably the most popular subjects, not only because of their variety, but because they are present from early spring through late fall. To many, the spring wildflower offering is the most intriguing, and there are many photographic books on the market to prove this point.

However, there are a great many other subjects, animate and inanimate, that can be equally fascinating: squirrels, insects, particularly butterflies, moths and caterpillars; spider webs and their skillful builders; frogs, toads, lizards, snakes and turtles; snowflakes; fruit; plants; mushrooms and toadstools; and colorful autumn leaves, to name a few. There is a year-round cornucopia of subject possibilities.

One of the best ways to gain access to some of these subjects is to take advantage of the various free nature field trips conducted by naturalists at state and national parks and forests throughout the nation. Many areas have self-guiding nature trails that provide excellent photo opportunities.

In this type of nature photography, the subjects range in size from fairly small to almost microscopic, and sometimes aren't easily found. Seeking them out can be much like a treasure hunt, adding a sense of adventure to the project. Some shutterbugs consider this to be the most enjoyable and satisfying of all photographic pursuits.

Movement caused by wind is often a problem when you're trying to photograph a flower. A simple solution is to tie the flower's stem to a wooden dowel pushed into the ground.

PHOTOGRAPHING BIRDS

One reason birds get the most attention is that they can be attracted to feeders. Once feeders are in place, it doesn't take long for birds to start coming to them regularly. With photography in mind, you should place feeders in an area that provides a natural background of shrubs, vines, flowers or trees.

Perches placed near a feeder will be used by birds on the way to and from it. Usually, birds will perch in trees or on rooftops and watch the feeder, then fly toward it, often

A portable tent will block the wind and soften harsh sunlight. To assemble the tent, push two bent tent rods (right) into the ground in an igloo shape around the flower to be photographed. Then (middle left) drape a sheet of translucent plastic over the frame and fasten to the ground with rocks. To soften harsh sunlight (middle right), a sheet of white ripstop nylon fabric can be draped over the plastic. Without the nylon covering you can see the frame and the photographer at work (bottom).

A photographer's lighting umbrella mounted on a small tripod is used here to soften harsh sunlight on a flower.

stopping on a perch before the final approach. This is the photo opportunity.

Perches of different shapes and sizes will provide variety in the photographs. They can be pieces of tree limbs or stumps, and they should not be permanent. One way to have moveable perches is to drive stakes into the ground and attach the perches to them with wire or automobile hose clamps. Perches can also be mounted on flat bases that can be weighted with rocks and easily turned or moved. Also, a small limb attached to the base of a pole-mounted feeder works very well as a photography perch.

By using moveable perches, you can take advantage of the light at different times of the day or in different seasons. Feeders made of natural material such as hollowed-out tree limbs filled with seeds or suet can be used as a combination feeder and photography perch. These work particularly well with chickadees, wrens and titmice.

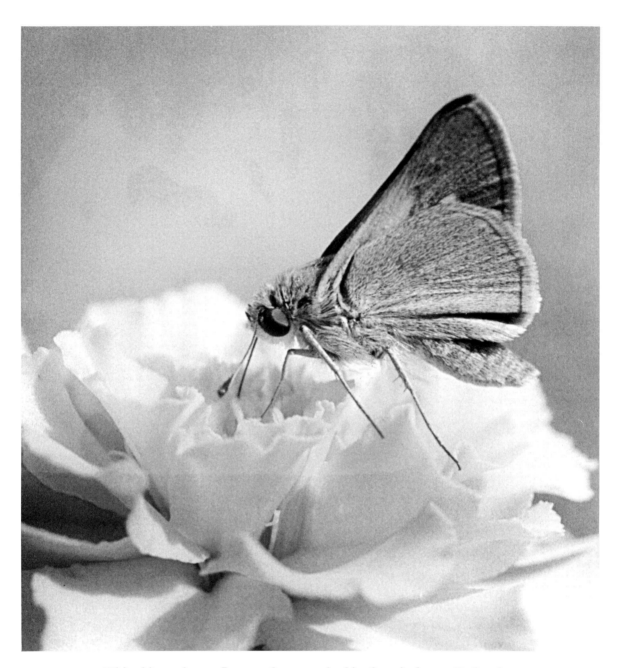

This skipper butterfly was photographed in the wind tent. By leaving the tent open over the flowers, the photographer caught several of these little butterflies inside.

Spiders are fascinating subjects. This photo of an Argiope spider was taken in late summer, the best time of year to find these insects.

This tiny spider was photographed with a macro lens on a vine that was about the size of a match.

A tree branch with a diameter of 6 to 8 inches turned on end and placed in the ground is another good combination feeder/photography perch. The suet is placed in holes drilled into the wood. This is a good way to keep starlings from eating the suet because they can't cling to the vertical surface, and it is especially attractive to woodpeckers, nuthatches and brown creepers. Turn the post so the holes are on the side and the birds can be photographed in profile.

In order to get close enough to the birds for full-frame photographs, a blind can be erected. The material used to con-struct a blind is unimportant, and it can be a temporary or permanent structure. The only requirements are that it is roomy enough for you and your accessories and has an opening through which you can take photographs. If the opening in the blind is too big for total concealment, wear camouflaged gloves, hat and face mask, and cover the camera and lens with cam-ouflaged fabric.

Place the blind 10 to 15 feet from the perches, depending upon the focal length of the lens you're using. Through trial and error you can establish the proper dis-tance. A distance of around 10 feet is ideal

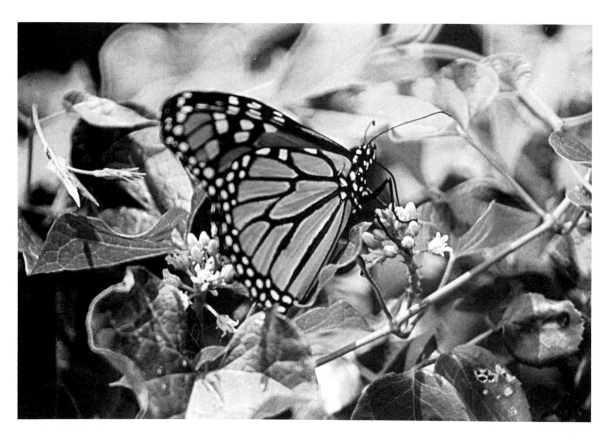

Monarch butterflies migrate in the spring and late summer. This one was captured with a 300mm lens with an extension tube. The camera was on a monopod.

for a 100–300mm zoom lens or a 500mm reflex lens.

Another suitable blind is a window. Feeders and perches can be placed outside a window and photographs taken from inside the house. Precautions must be taken to avoid reflections when photographing through glass. The screen should be removed, and if there are storm windows, one should be open. Clean the glass thoroughly and place the camera lens as close as possible to the glass. If the weather permits, open the window and fasten a fine mesh fabric across it with a hole cut in it to accommodate the lens. Material such as cheesecloth will enable you to see the area around the feeder while remaining hidden from the birds.

This procedure is especially suited for apartment dwellers who don't have a backyard. Balconies are usually small enough to take pictures from inside through a clean glass door. You can place a feeder on a patio or balcony near a perch, and a remote can be set up just outside a door, making sure the camera is protected from the elements. This technique will be explained later in the chapter.

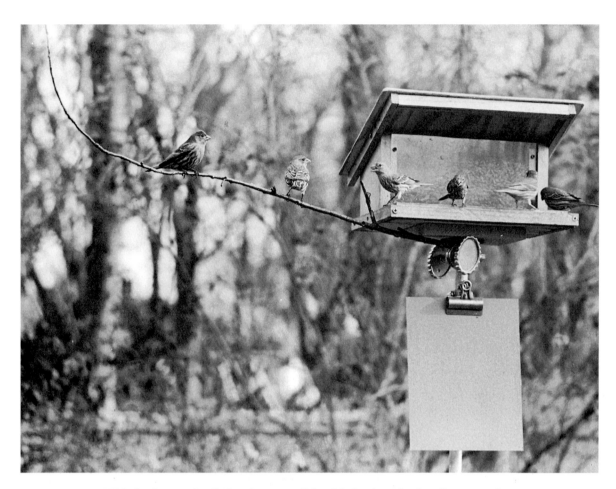

This feeder was built for photographing birds. Attached to the mounting pole is a photographer's umbrella clamp that holds a small limb. Underneath the limb, a clamp holds a gray card on which to meter the scene. Birds using the feeder will perch on the limb long enough for a picture.

With a long lens on his camera, the photographer prefocused on the limb and waited until the birds were in position.

If you are setting up bird feeders on apartment balconies above the first floor level, it is important to consider the people who live below. Birds are messy, and seed hulls and droppings aren't always welcomed by neighbors.

When using a blind, pre-focus on the perch, set the shutter speed and f/stop, and wait. Patience is the key to getting good photographs. Let the birds come and go a few times before you begin taking pictures. When a bird sits on the perch, fine focus quickly and make the exposure. Don't stop with one image. The bird won't stay long, so take a series rapidly. If your camera is equipped with a power film advance, this can be accomplished in a few seconds. Small birds like wrens and chickadees move about quite fast, and large birds seldom stay in place for as much as a minute. A flat, open feeder with a perch attached may keep the birds posed longer.

It's easy to get caught up in watching birds instead of taking pictures, but the time for observation is before and after the photography session. It can be very helpful to the photographer, though, since the more that is known about a subject the better the photographs will be. Observation is the best way to become familiar with the habits of birds at feeders. Notice the aggressiveness of some species and the timidity of others. Note which birds eat at the feeder and which ones carry the food away. Watch woodpeckers, chickadees, tufted titmice and jays hold the seeds with their feet and pry them open with their beaks. This activity can keep

the birds occupied long enough to take several photographs.

Birds aren't the only wildlife attracted to feeders. Squirrels are particularly fond of sunflower seeds, and if there are any in the vicinity, they can be expected to conduct raids upon the feeders. Annoying as it may be, it is also a good photo opportunity, since squirrels are interesting subjects.

FLASH

If a flash is to be used it should be mounted on a stand as near the perch as possible without being in the picture. Determine the f/stop for the camera and connect the flash to the camera with a long P.C. cord. If the flash has a camera mount (hot shoe), purchase a mounting adapter which will also carry long flash extension cords. The flash can also be used on the camera, but off-axis lighting achieved with off-camera flash looks more natural and accentuates detail.

If the birds are shy of the flash unit, put a decoy flash in place for a few days. Find a box or a block of wood that is of the approximate shape of the flash. Paint it to resemble the flash and leave it up until the birds become accustomed to its presence, then replace it with the actual unit. With the exception of wild turkeys and crows, most birds are easily fooled. Birds in urban areas are not shy of inanimate objects and quickly become accustomed to changes. An alternate to a decoy flash is a permanent shelter for the unit. One can be erected which will allow consistent exposure, because once

the formula is established, the distance from the flash never varies. A small, wooden, three-sided box with a ¼-20 bolt through the bottom will hold a shoe-adapted or handle-mount flash.

The light from the flash doesn't seem to frighten birds; it may be that it resembles lightning. However, they are disturbed by sound and movement. If birds are alarmed by the photographic equipment, consider making exposures at their alternate visits to the feeder.

REMOTE PHOTOGRAPHY

Another method of photographing birds and other nature subjects from a distance is with remote control. The key to getting good remote pictures is planning. With the camera on a tripod, focus on the front edge of a perch. Select an *f*/stop that will provide the maximum depth of field and set the corresponding shutter speed. If your camera is equipped with an electronic release, connect the release cable to the camera (check the camera's instruction book). Wait until the bird is in place and trip the shutter. On cameras that advance film automatically, successive shots can be made. If the camera can't be equipped with an electronic release, an air release can be used. This consists of a squeeze bulb, a long, hollow tube, and a pneumatic plunger. The plunger fits into the cable release socket; when the bulb is squeezed, the shutter is tripped. The tube on an air release is 10 to 20 feet in length, which is ample for remote photographs. Air releas-es have been around as long as shutters, but they may be hard to find today except in camera stores with a full inventory, or through photo mail-order catalogs.

A radio release provides another way to make remote pictures. Available at most camera stores, these radio units are used by many location photographers to connect electronic flash units to the camera. They can also be used with a camera equipped for electronic release.

Remote equipment can make close-up photographs without using a long lens. Interesting angles and creative composition can be accomplished when photographing from a distance. The drawbacks of remote photography are the inability to actually see what you are photographing and ascertain the need for changes in exposure or focus. This is a situation where autofocus and automatic exposure works well. If you compose the photograph so the subject fills the frame, the exposure should be accurate. If the subject occupies most of the viewing screen, the autofocus should work well. If flash is used for remote photography, exposure will be constant. If manual exposure is used, take the photograph while the light is constant. When using manual focus, select a small *f*/stop so the depth of field will correct minor errors in focus.

When using an automatic exposure camera remotely it is important that you cover the eyepiece; otherwise the exposure will be affected by light entering it. Some cameras have a provision for closing the eyepiece, or it can be covered with black masking tape.

Remote photography is a good way to

A camera equipped with a radio-control remote release was focused on a hummingbird feeder. The photographer watched from a distance with binoculars until the bird was in position, then triggered the camera with a small transmitter.

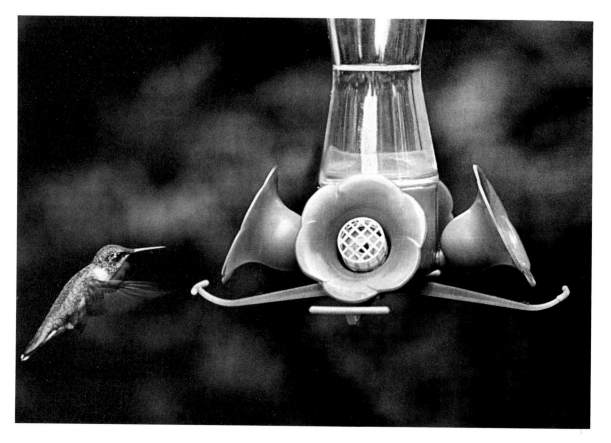

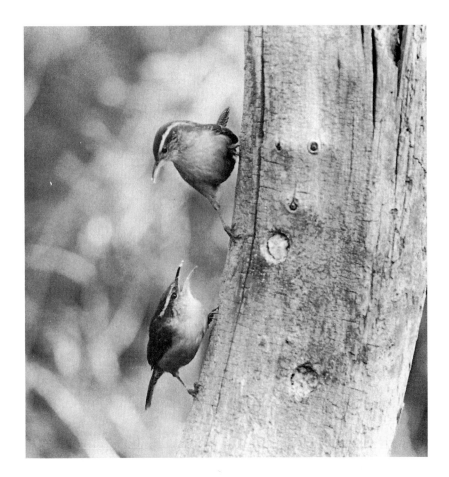

An old tree limb was placed in the ground near a blind in the photographer's backyard. Holes were drilled in the limb and filled with suet. These two Carolina wrens were photographed when they came to feed on the suet.

This chipping sparrow was perched on a limb attached to a feeder. The picture was taken from a window about six feet from the feeder. The open window was covered with thin cloth into which a hole had been cut for the 300mm lens.

photograph birds at nesting boxes. A box to hold a camera can be erected near the nesting box. It should be in place before the birds start building their nest so they will not be disturbed. The camera box should be insulated to deaden the sound of the shutter and film advance. A small flash can be attached to the camera, either to light the subject or pointed toward the photographer as an indicator that the camera is operating. The lens opening of the box should be covered with a clean sheet of glass, which also helps to deaden sound. A cover can be fashioned to keep the glass clean when the box is not in use. When the birds are feeding their young they are likely to tolerate some disturbance, but it should be kept to a minimum. Of course, telephoto or zoom lenses can be used in place of remote setups.

10

Scenics

More film is probably exposed on scenics than any other outdoor subject, and it is understandable why. All sorts of thrilling and exciting views beckon the photographer: beautiful landscapes, spectacular sunrises and sunsets, majestic mountain views, seascapes, glowing displays of fall leaf colors, old barns and houses, covered bridges, stone fences and many more.

A photographer visiting, say, the Rocky Mountains or the Oregon Coast for the first time is likely to encounter a thrilling view around every curve in the road, each of which may appear to be highly photographic. It's a temptation difficult to resist, but before grabbing the camera and "shooting from the hip," so to speak, take time for a second look. What you see may be pretty, yet upon closer examination prove to be less appealing than at first glance. This is the time to use the mask described in Chapter 5 to get a better idea of how the scene will actually look in a photograph. Once you make this simple test, you can better determine whether or not the scene will produce a good image.

Amateur photographers often have the idea that good pictures can be taken only on bright, clear days, but this isn't true. Inclement weather often offers the opportunity to produce exceptional images with either color or black and white film. The secret lies in using a tripod and choosing the proper film and lens combination.

LENSES FOR SCENICS

Normal or wide-angle lenses usually are perfectly suitable for photographing scenics, but zoom and telephoto lenses have certain advantages.

First, more often than not, you must take a scenic shot at a spot such as an overlook on a roadside or trail that is a set distance from the subject. You have only two

This winter scene was taken in early morning when the sun was casting shadows across the yard. The sky was enhanced with a polarizing screen and exposure was measured with the camera's meter off the gray house. A 24mm wide-angle lens was used to get a broad view.

choices to create an effective composition: holding the camera in a horizontal or vertical position. With a zoom lens, the frame can be adjusted to eliminate any undesirable or superfluous elements in the scene, and with a long-focal-length lens, key elements in the scene can be isolated.

Beautiful black and white pictures can be taken in rainy weather. This scene (at right) was shot on ISO 400 b/w film with 70–150 zoom lens in the 150 position. An assistant held an umbrella over the photographer, and when it was time to make an exposure, the assistant whistled and the horse looked at the camera.

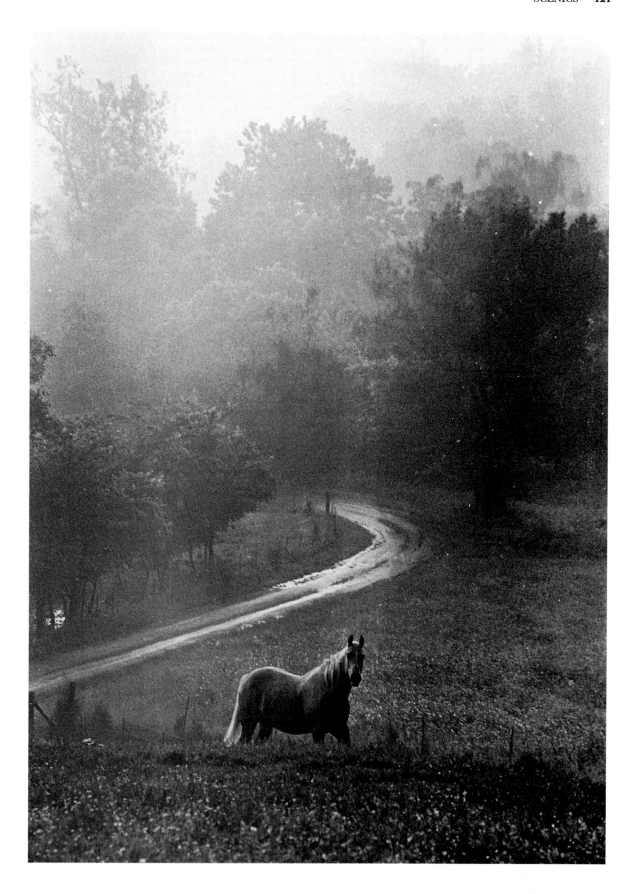

This photograph was taken with a wide-angle lens on ISO 100 b/w film on an overcast day. The photographer waded into the river and steadied his camera on a tripod.

Second, long-focal-length lenses tend to "squeeze" the foreground and background so they appear to be closer together. This produces an unusual and attractive effect, and is particularly dramatic when photographing mountains where there are successive layers of hills in the background.

One way to give balance and more appealing composition to outdoor scenes is to include an object or objects in the foreground to lend depth. A fringe of foliage or flowers on the side, top or bottom of the frame will produce this effect.

This can also be accomplished by including leaning tree trunks, rock outcrops or other objects in the foreground. Regardless of the subject, many scenic photographs appear flat and uninteresting due to a unimaginative composition.

The dog in this picture was in the company of kids swimming in the river. The photographer framed the picture to exclude the people, focused on the dog, and whistled at the last moment, causing the dog to look at the camera.

11

Sports and Other Events

Outdoor sports activities offer an enormously wide range of photo opportunities with everything from point-and-shoot cameras to the sophisticated equipment used by professional photographers. In most cases the subjects are in motion, and often proximity to the action is very important to the quality of images that are produced. A good example would be pictures taken from the stands of a football game as opposed to those produced by photographers on the sidelines set up with tripods and zoom or long-focal-length lenses. Gaining access to the sidelines of high-school football games is usually easy, but when it comes to college and professional events, photographers are seldom permitted without special media credentials. The same applies to basketball and other indoor sports where space is limited.

The good news is that there are plenty of other sporting and outdoor activities without such restrictions. It would be impossible to list them all, but a partial rundown would include whitewater rafting, canoeing or kayaking; steeplechase races; polo; soccer or rugby games; tennis and golf matches; water sports; winter sports; mountain and rock climbing; track and field sports; skeet, trap and sporting clay meets; bike races; boat races, and marathons.

Some of these events test the skill and often the physical ability of the photographer. Shooting good images of sports events depends upon the ability to identify and capture unusual views and angles.

Some events allow the photographer to be a participant. Here the cyclist is about to photograph his competitors. A compact camera is needed for events like these.

You have to consider camera position, lighting, and the most suitable lens lengths. These factors can make the difference between ordinary and eye-catching photos.

In addition to sports activities, there are many colorful and interesting events that can provide photographers with a kaleidoscopic array of subject material, as well as the opportunity to use their imagination and creativity in producing outstanding images. County fairs, festivals, air shows, antique car and aircraft exhibits, hot-air balloon meets, Indian pow-wows, story-

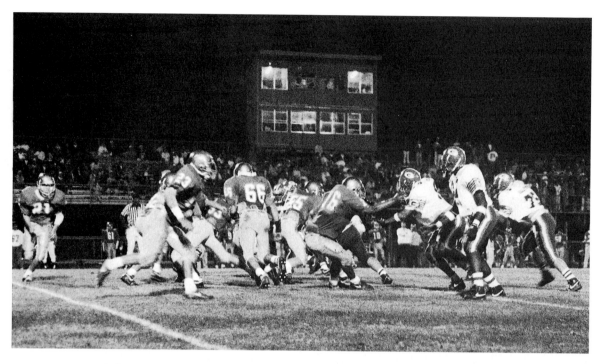

High-school football games are not as restricted as college and professional sports. Most high-school games can be photographed from field level. This picture of a night game was taken with a 300mm lens on ISO 1600 film, with the camera on a monopod.

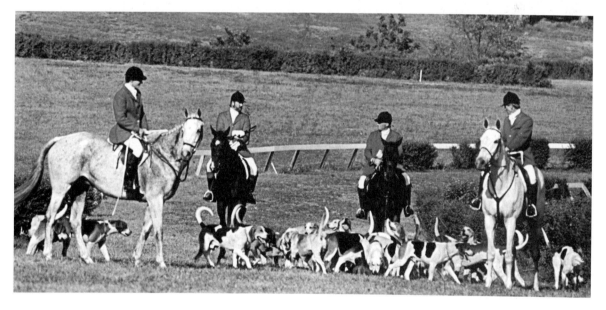

This picture was taken between races at a steeplechase. To gain entry to such events, contact the sponsor and ask about press passes. If you have a legitimate need for pictures, whether you are a pro or amateur, you may get in.

Balloon events seem to be made for photography. This scene was taken with a panoramic camera that takes a 140-degree view with a moving lens. These cameras can be rented from some camera stores.

telling events, Scottish clan gatherings, skydiving, parasailing, hang-gliding and Civil War battle reenactments are just a few of the endless possibilities.

It should be mentioned that good physical conditioning is essential when photographing some of the activities listed, since they are strenuous and involve lengthy exposure to the elements. Anyone participating should check in advance to determine what to expect and proceed accordingly.

EQUIPMENT

While many kinds of cameras and lenses are suitable for photographing sports and events, the most practical, all-round choice is a 35mm SLR autofocus camera with 28mm-70mm and 70mm-210mm zoom lenses. This range of lens capabili-ties will be adequate for virtually all situations. The exceptions would be cases where specialized or long-focal-length lenses are required, and these can usually be anticipated and the proper equipment assembled well in advance.

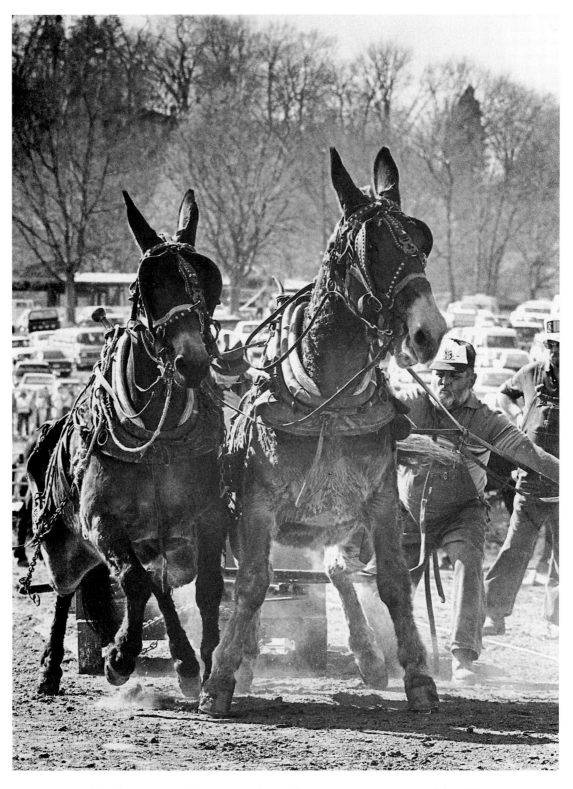

This picture was taken at a mule-pulling contest at a county fair with a 300mm lens. The camera was mounted on a monopod. Often back-lighting adds drama to a scene.

12

Celestial Photography

Celestial photographs can be taken with 35mm cameras in several ways. Lunar photographs can be made by using either a long-focal-length lens or a good telescope equipped with a camera adapter. Star trails can be recorded with a normal lens. Constellations and deep space objects can be recorded with a very powerful telescope equipped with an equatorial mount that keeps the telescope synchronized with an object in the sky. This compensates for the earth's rotation and keeps the subject steady in the lens for long exposures.

To photograph the moon you need only a sturdy tripod, a long lens and medium-speed film. The focal length of the lens must be from 500mm to 1000mm to reproduce an image large enough to have detail.

The pictures of the moon in this chapter were taken with a Bausch & Lomb Elite 77mm spotting scope equipped with a camera adapter. In the case of this scope, 77mm refers to the diameter of the lens, not the focal length. With the camera adapter the focal length is 800mm with an equivalent f/stop of 11.

A misconception about photographing the moon is that it requires a long time exposure. The moon is lit by full sunlight, so photographing it is much like photographing a desert. Since the moon has no atmosphere, the sunlight striking its surface is always bright. We do, however, have to photograph the moon through the earth's atmosphere, which makes exposure the same as it is for normal bright sunlit scenes.

How to determine exposure? Simply use the "Sunny 16" rule and bracket. On a bright day set the lens at f/16 and use a shutter speed that is nearest the ISO of the film you are using. The moon picture shown was taken with ISO 100 black and

Pictures of the moon can be taken with a long-focal-length lens or with a telescope that has a camera adapter. As the moon is illuminated by the light from the sun, it can be photographed with a short exposure.

white film, which required a shutter speed of 1/125 second.

The telescope has only one *f*/stop, 11, so to have an equivalent exposure the shutter speed is set at 1/250 second. The same amount of light reaches the film at 1/125 second at *f*/16 as it does at 1/250 second at *f*/11.

To bracket the exposure, change shutter speeds. Make an exposure at 1/125 second, another at 1/250 second and another at 1/500 second. If a standard 800mm or 1000mm lens is used, you can bracket *f*/stops in the normal way. Through-the-lens metering can also determine exposure, but it's wise to bracket to be sure of obtaining the best exposure. Remember that because the moon is illuminated by sunlight its color temperature is about 5500 degrees

Kelvin, daylight (see color temperature section, Chapter 3).

The moon is in an elliptical orbit around the earth and is not always the same distance away. The nearest the moon comes to earth is 221,456 miles and its greatest distance is 252,711 miles. This makes the mean distance 238,857 miles. The moon's size is about 2160 miles in diameter, and its distance from earth makes it a small subject to photograph.

That's why photographers are often disappointed that the big, full moon they saw appeared so small in photographs taken with normal lenses. Even with an 800mm lens the moon will not fill the frame of a 35mm negative.

The moon is seen from earth in eight phases, from a new moon barely visible in the sky to the full moon and back. This cycle takes about 29 days. The phases are caused by the moon's orbit around the

A Bausch & Lomb Elite 77mm telescope with a camera adapter was used to take the picture of the moon on page 132. The front lens element is 77mm in diameter; the focal length of the lens is 800mm with an equivalent f/stop of 11. The photograph was taken at 1/250 second at f/11 on ISO 100 film.

earth and the earth's orbit around the sun, causing the earth's shadow to cover part of the moon most of the time. We only see one side of the moon's surface, even though it's rotating, because the moon turns once on its axis at the same time that it orbits earth.

Sometimes the moon looms large and red in the evening sky. This phenomenon is caused by the light from the moon striking earth at a low angle. The earth's atmosphere bends the light rays, causing an enlarging effect. The red color is also caused by the atmosphere. From an observer's viewpoint, at a low angle to earth light in the blue end of the spectrum is filtered by the atmosphere much as is a sunset. When the blue light is filtered out, red becomes the dominant color. As the moon rises in the sky it appears normal in size and color.

STAR TRAILS

A normal lens, medium-speed film (ISO 100), a sturdy tripod and a cable release are all the equipment needed to photograph star trails. Simply point the camera at the North Star in the Northern Hemisphere or the Southern Cross in the Southern Hemisphere. Set the focus at infinity, the shutter speed on bulb and select a mid-range *f*/stop. Using the cable release, open the lens and keep it open for 15 minutes. Make several exposures at different lengths of time. This time exposure will record the stars as they appear to move through the night in long trails due to the earth's rotation. Interesting surprises await in the film development. Satellites and meteorites will leave trails that don't match those of the stars.

Skies above areas far from city lights and air pollution are best for celestial photography. In most parts of the country, a clear winter night is the perfect time to record star trails. Ideal places are high mountain and desert regions. To add interest and scale to your celestial photographs, include a horizon of trees or houses.

13

Underwater Photography

Underwater photography using scuba gear presents a unique set of problems, the most important of which is personal safety.

Scuba diving is both exciting and rewarding when practiced properly, and today's equipment is highly sophisticated and dependable. Still, caution must be exercised.

Before the invention of the aqua-lung, better known as scuba (an acronym for self-contained underwater breathing apparatus), divers were forced to use heavy suits and diving helmets. Scuba gear gives the photographer great flexibility and mobility.

Do not attempt to use scuba gear *without receiving lessons from a certified instructor.* Actually, it's unlikely that you could dive without being certified, because such proof is required to have air tanks filled. Air from an ordinary compressor contains particles of oil and other debris that can get into a diver's lungs. That's why air tanks must be filled using a special compressor operated by qualified technicians.

Photographers who don't want to dive but can swim can capture good underwater photographs by snorkeling. There are several advantages to snorkeling: it requires little equipment; the camera doesn't have to be pressure-proof; and it's quite safe. Many interesting subjects can be found just below the surface.

CAMERAS AND LENSES

Several options are available to the underwater photographer: underwater cameras built to withstand the pressure of water at depths of greater than 10 feet; underwater housings for standard cameras, also designed for the pressure of deep water; and waterproof cameras that can be used at depths less than 10 feet.

The best lens to use is a wide angle,

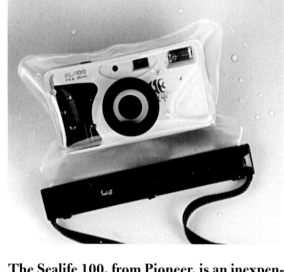

This disposable underwater camera can be used to a depth of ten feet. These little cameras are ideal for beginners using snorkels.

The Sealife 100, from Pioneer, is an inexpensive focus-free camera with a 35mm f/5.6 lens, built-in flash and automatic film advance. Encased in its flexible housing, it can operate to a depth of sixty feet.

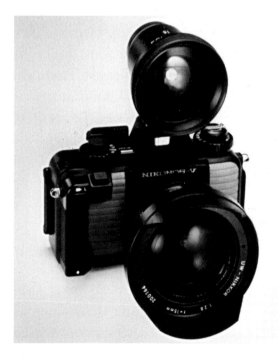

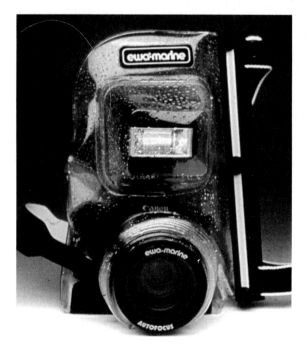

Nikons V has five interchangeable lenses and through-the-lens exposure metering in two modes, manual and aperture-priority automatic. This latest version of a proven underwater camera has been on the market since the 1960s; it can be used to a depth of 160 feet (50 meters).

This Ewa Marine underwater housing, from Pioneer Research, will accept a standard SLR as well as the maker's own autofocus camera shown here.

from 28mm to 35mm. The natural magnification of objects underwater affects a lens by increasing its focal length. A 28mm lens will be equal to a 37mm lens and the angle of view decreased. The short focusing range of a wide-angle lens stopped down will correct minor errors.

LIGHT

The photographic problems that must be solved by the diver/photographer involve the action of light passing through water. When light rays pass from air to water they are refracted, or bent. This refraction causes objects to appear larger than they actually are. An object 8 feet away will appear to be only 6 feet away, a factor that makes judging distance for zone focusing and manual flash calculation difficult, since objects will seem about one-fourth closer than they really are.

When sunlight strikes the surface of the water, some of it is reflected. When the rays strike the water at an angle, as they would late in the day, or when the water is choppy, the water reflects more light than it does when the sun is overhead or the water's surface is smooth.

Also, not all of the light that penetrates the surface will reach an underwater subject. Some will be absorbed and scattered by air bubbles near the surface and suspended particles in the water. To sum it up, the amount of light that reaches the subjects depends on the depth of the water, the surface conditions, the clarity of the water and the time of day.

CHANGES IN COLOR

As sunlight travels deeper below the surface of water, certain colors are absorbed. The blue-green color of water acts like a filter and absorbs the colors at the red end of the spectrum. As light travels deeper, more red is absorbed and the color of the surroundings becomes progressively more blue. The first color to disappear is red, which is diminished somewhat at 10 feet; at about 25 feet below the surface objects that are red appear to be brown. Orange disappears at about 30 feet, followed by yellow. At 100 feet, green is diminished and the entire underwater world is a monochromatic blue. There is an interesting exception to the absorption of warm colors by blue water. Objects painted fluorescent retain their colors at all depths.

As you dive deeper the loss of warm colors may not seem obvious because the brain makes certain adjustments to one's mental vision. This same thing occurs when in a room lit with fluorescent lights, which are green in color. A person's color vision adjusts to a point at which fluorescent lighting looks natural. Color film doesn't make such adjustments so when your underwater photographs are developed they will appear bluer than you remember the scene.

UNDERWATER FLASH

Before the advent of good electronic flash units, underwater light was supplemented with a clear flashbulb. These bulbs were

designed to produce light that is the same color as a tungsten light bulb, which is red. By using flashbulbs that produced light in the red spectrum of about 3200 degrees Kelvin, the loss of red underwater was somewhat corrected (see section on color temperature, Chapter 3).

The light from an electronic flash measures about 5500 degrees Kelvin, which is toward the blue end of the spectrum. This is the color to which daylight film is balanced. To add red to the light from the flash, cover the face of the flash with a filter such as a CTO. This will absorb blue and change the color of light to the red end of the spectrum from 2900 to 3200 degrees Kelvin. These filters are made to be used to

cover lights for motion picture and commercial photography. They are commonly referred to as "gels," short for gelatins, although they are actually made from a vinyl-like material. Theatrical supply houses and some camera stores sell gels, and they can be bought from some mail-order houses. Gels are available in densities of ⅛, ¼, ½ and full color. Two popular brands of gels are Roscoe and Lee.

If the face of the flash unit is less than 3½ inches in width, it can be covered with a Kodak CC (color correction) gelatin filter. A good choice is an 85B. These Kodak filters require a special holder mounted on the camera lens. However, when a CC filter is placed over the lens the whole scene will

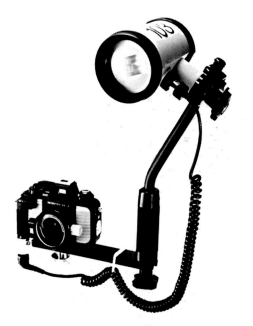

An SB103 Speedlight from Nikon is mounted on a bracket that places it at the proper angle and distance from the camera.

Two SB104 Speedlights are mounted on Nikon's RS-AF camera, an underwater SLR with one of the world's first underwater zoom lens. The RS can operate to a depth of 328 feet (100 meters).

Shallow-water diving with a simple camera can result in good underwater photos of coral and fish.

be warm in color. If the filter is over the flash, only light from the flash will be warm and the photo will look natural.

DETERMINING UNDERWATER EXPOSURE

An exposure meter in an underwater housing is the best way to determine nat-

ural light exposure, and you should bracket ½ to 1 *f*/stop on either side of the indicated exposure (see Chapter 4).

Flash exposure can be determined in several ways. A flash meter can be placed in an underwater housing, but this isn't practical because the controls for operating a flash meter are complicated. The automatic features of an electronic flash will work but may not always be accurate.

Include another diver in your photographs to give scale to the scene. Since one of the cardinal rules of diving is "never dive alone," you'll always have a subject.

The light sensor, or thyrister, which determines automatic exposure, is on the face of the flash unit. When mounted on a bracket, it may be as much as a foot from the camera. This will be good enough when you are using negative film because some correction can be made by the photo lab. With slide film, which requires exact exposure, the exposure may be off since it is determined by the distance from the flash to the subject. Because of this, the sensing unit should be attached to the camera, and this is often impractical with underwater equipment. Still, even with this arrangement you will most likely get good images if you bracket the exposures. If the exposure calls for $f/11$, make one exposure at that setting, one at $f/8.5$, another at $f/8$, then take one at $f/11.5$ and one at $f/16$. This is a full range of brackets

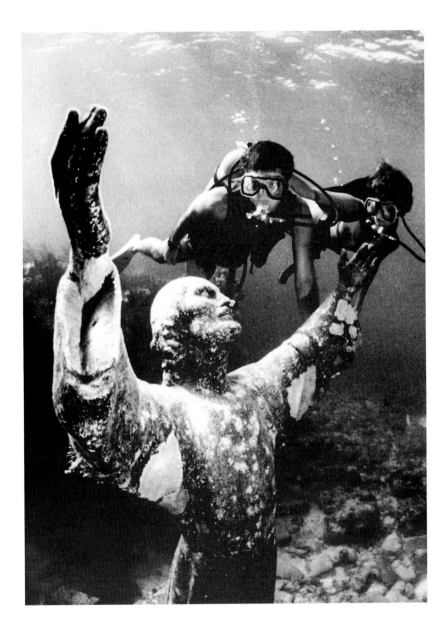

This photograph was taken at John Penneycamp Coral Reef State Park at Key Largo, Florida, an underwater park popular with photographers. The statue, Christ of the Deep, is a 9-foot-high bronze that rests in 21 feet of water.

that should get one good exposure.

Another way to determine exposure is by the use of guide numbers (see Chapter 6). Electronic flash units are assigned a guide number based on the output of the unit. This number, when divided by the distance from the flash to the subject, will give you an *f*/stop around which you can bracket. The guide numbers for any elec-

tronic flash are printed in the instruction book that comes with the unit. Water is about 800 times the density of air, so light traveling through this dense medium is slowed down to about one quarter of its speed through air. This causes the refraction mentioned earlier which affects exposure calculation. To compensate for the density of the water and the suspended

particles in the water (turbidity) divide the guide number by four to get the underwater number.

Make some tests before you take a serious photography dive. Check out both yourself and your equipment in a swimming pool. Work out exposures up to 15 feet at increments of 5 feet and record the data on a plastic card that can be attached to the camera. Use these predetermined *f*/stops and bracket the exposures.

The best pictures will be those taken in clear water at depths of less than 20 feet using flash fill to supplement natural light. Use the above-water guide numbers to determine fill flash. The density of the water will diminish the flash enough to allow the natural light to illuminate most of the scene. Here again, bracket the exposures.

Suspended particles in the water can cause a condition called "backscatter." These particles can reflect light from the flash back into the camera lens, creating a cloudy look. Backscatter is actually a picture of suspended particulate. This condition occurs when the flash is too close to the camera. To eliminate backscatter, move the flash away from the camera at an angle of about 30 to 45 degrees to the subject from the camera axis.

FILM

As with any photography, the slower the film used underwater, the finer the grain, which results in sharper pictures. When working at depths less than 10 feet a film with an ISO of 100 will yield excellent results. A very good slide film to use is Kodak's E100SW, a very fine-grained film with a built-in warm bias. When a faster film is called for, try Fuji Provia 400, a fine-grain film with an ISO of 400. Either of these two films can be push-processed with good results (see Chapter 3). Good color negative films to try are Kodak or Fuji in the 100 to 400 ISO range. If there is enough light, Kodak's Ektar 25 (ISO 25) color negative film produces spectacular prints. Black and white pictures taken underwater should be made with color negative film, since both black and white and custom color slides can be made from color negatives. Even if you have a particular reason to shoot black and white images, you may wish to have color reproductions at a later date. The black and white underwater photographs shown in this chapter were made with color slide film and converted to black and white by making a black and white internegative (see Chapter 3).

14

Traveling with Your Camera

Traveling with camera equipment poses potential problems and hazards that are not encountered under ordinary circumstances. Because of this, there are certain rules that should be followed. The first two are the most important.

• Never check your camera bag or case. Make sure it is in your possession, or within reach, at all times. This is why it is important to have one that will fit in overhead or underseat storage spaces. Checked baggage is often subjected to extremely rough treatment. Also, a camera bag or case is easily identified by thieves. It can be stolen either en route or taken off the baggage carousel at the airport before you locate it.

• Don't allow film to be passed through airport X-ray machines. Remove it and pass it around the monitor to the attendant. They can visually inspect it if necessary. Do this regardless of what claims may be posted stating that the equipment will not damage film.

• If you are traveling to a foreign location, it is wise to register your camera equipment with the U.S. Customs Service. This prevents problems with officials in other countries who might assume that you purchased it while on your visit and must pay duty. The form is free and simple to complete, and you should have the equipment with you when you obtain it, since it has to be witnessed by a customs official. There is another benefit. If your camera equipment is stolen when abroad, the form will provide proof to your insurance company that it was with you on the trip.

When traveling into the backcountry always take a first-aid kit, a compact flashlight, waterproof matches or a fire-starting kit, drinking water, compass and maps of the area. Familiarize yourself with the maps and compass before you go.

• Place camera bodies and lenses in plastic bags for additional protection against whatever elements may be encountered in the field. Even though some camera cases have airtight seals, the equipment is vulnerable to moisture, dust or sand once opened. The bags come in sizes from one half pint to one gallon, and in regular and freezer-weight. Select the latter; they're more durable.

• Start any trip with fresh batteries in the camera and flash unit, along with a back-up supply. There's no guarantee you can find them in some places, and even if you do, they may not be of good quality.

• Develop a checklist for travel that includes not only those things you usually carry in your camera bag or case, but also those that may be needed in an emergency for equipment repair. Electrical or strapping tape, super glue, a jeweler's screwdriver set, a length of thin wire, and a

In cold weather always keep these items with your camera: a thermal cap, chemical warmers and gloves with open fingers that let you operate the camera.

magnifying glass are a few examples. It is better to have a few extra items than to be without what you need.

• Make certain that film remaining in cameras at the conclusion of the trip is removed before starting home. This is easy to overlook, and will allow it to be exposed to X-rays when the camera bag or case is passed through the monitor.

• If you anticipate taking photos of people, it's a good idea to have a number of pocket model releases such as those illustrated in Chapter 15. Better still, have them printed in the language of the country you will be visiting. Ordinarily you won't encounter any problems, but it's better to be safe than sorry.

15

Selling Your Pictures

We live in a time of visual communications. Millions of photographs are published each day in magazines, newspapers, catalogs, greeting cards, advertisements, posters, on book covers, music albums, electronic books and many other places. The need for good photographs is constant, and there are many opportunities for outdoor photographers to sell their work.

However, certain criteria must be met in producing a saleable image. Obviously, the photograph must be well crafted, which means properly exposed, sharply focused and well composed. In addition, the photograph must meet the needs of the publisher by relating to a story, a product, particular subjects or seasons. The best way to determine what a publisher is likely to purchase is to go to a newsstand, bookstore or public library and do some serious research. Look at the illustrations that appear in the outdoor or nature publications that use your

kind of photographs. Inside the magazine are the names and addresses of the editors and art directors, both of whom can be contacted with a request for their editorial guidelines, which will include information on photographic submissions. Do not request this material by phone; instead, send a query letter along with a self-addressed, stamped envelope.

Calendars and greeting cards usually have the publisher's name and address on them. Just as with magazines, it's important to study them to see what kind of photography they favor.

Advertising agencies buy stock photographs for print ads, TV commercials and package designs. Some of these images are obtained directly from photographers, although most are selected from stock picture agencies that represent photographers. Photographs used for advertisements have great value because they

help to sell products and therefore command higher prices than those used in editorial matter. Of course, when a stock picture agency sells a photo it receives a percentage of the proceeds. This figure may vary with different agencies, but 50 percent for domestic sales of color pictures is a normal commission. It may be less for black and white photos or for foreign sales. Poster, calendar and greeting-card publishers rely heavily on stock agencies for images. One thing to remember: A stock agency may require an initial submission of 100 to 1,000 images from photographers in order to represent them.

Beautiful photographic prints, matted and framed, can be sold at frame shops, art galleries, and craft fairs. Remember, however, that enlarging a picture and putting it in a frame doesn't automatically make it a piece of art. The picture must be very good and presented well. Avoid colored mats. Mount the print in a white mat and use a simple metal frame. Photographs displayed in the finest galleries and shows are displayed in this manner. When a person buys a print from a photographer he does not get any reproduction rights. He buys only a reproduction of the original for personal use. This must be spelled out in the sales contract. The photographer's copyright notice should appear on the mat or back of the print.

BREAKING INTO THE MARKET

A good way to break into the commercial sale of photographs is to make yourself known to local advertising agencies by showing your work to their art directors. This should be done by appointment, and your presentation should be businesslike and brief, with professional quality prints mounted on black or white boards or multiple slides displayed in black presentation mats. No matter what form is used, the work must be of very high quality. Such a meeting may not produce immediate results, but often leads to an assignment or sale later.

There are many other local possibilities for the freelance photographer, including chambers of commerce, which print promotional materials; local newspapers, which are always on the lookout for good, well-captioned photographs; trade associations, electric and gas co-ops and similar organizations which may publish magazines or other periodicals that need good photographs.

All state wildlife and conservation agencies publish magazines, and many buy photographs. These publications usually pay less than commercial magazines; nevertheless, they can be good markets for high-quality outdoor and nature photographs.

All photographers want to sell pictures that will be featured on magazine covers, yet many otherwise good photographs are never considered by an art director or an editor because they don't fit the format of their publication. The cover photograph is what grabs the reader's attention and makes him want to see what's inside. A magazine must compete with dozens of others on a rack, and this is evidence of the importance of being precise in the selection of subject material for this purpose.

Here are four simple guidelines for shooting magazine covers: (1) The picture must relate to a story inside. (2) With rare exceptions it should be a vertical image. (3) The background should be simple. (4) The main subject should be off center enough to allow copy to run on the left or right side. (5) Take close-ups and fill the frame with action or something of interest. (6) Above all, submit only your best photographs. If a publication requests 20 slides, don't send 20 variations of the same scene.

WHAT TO SUBMIT

Never submit your original negatives or slides. Before a photograph appears in print it must be handled by several people, all of whom will take reasonable care of it. However, an accident can destroy a one-of-a-kind image, and there is also the possibility of damage in shipping or mailing.

In the case of a slide or larger transparency, have the original duplicated by a good photo lab. You can make your own duplicates with close-up equipment and slide copiers, but they are usually inferior to those done by a professional lab. Duplicate slides from a professional lab can seldom be distinguished from the original.

Few if any publications ask for negatives. The pay usually offered for the use of a photograph is not enough to give up the original negative. If a negative is requested, have a print made from which a copy negative can be produced or have a photo lab make a copy negative.

If you submit black and white prints you risk only the loss of the prints themselves, since you have the original negative in your files. Nevertheless, prints are costly to make or have made, and they should be returned to you after they are used. Also, by asking that the prints be returned, you lessen the chance they will be used again without your knowledge or permission. Your copyright notice, mailing address and phone number should be on the back of every print, either on a label or printed with a rubber stamp.

Should a publisher insist upon using only original slides, have it agreed in writing that you will be paid for them in the case of loss or damage. A delivery memo should accompany the submission, which must be signed by the buyer and returned to you before the photographs are used. At this writing, an average payment for lost or damaged slides is $1,500 each.

Photographers often take "similars," which are multiple exposures of the same scene. Though not possible with action photographs, these similars can provide a file of duplicate original images from which to submit to publishers. One master slide should be stored safely to be duplicated in an emergency.

WHO OWNS THE PICTURE?

Notice that we speak of selling the use of the photograph as opposed to selling the photograph itself. The use of a good image can bring the photographer many sales over a period of time, income that would be lost

if the photograph is actually sold.

So, who owns the photograph? Under the Copyright Act of 1976 the picture is the property of the photographer from the moment of its creation. When the button is pressed, the picture is yours. It remains so unless the photographer assigns the copyright to another party in writing. For additional assurance that the photographer is protected, the photograph can be registered with the United States Copyright Office. By registering a copyright the photographer is entitled to recover legal expenses for a copyright infringement determined by a court of law. Registration is necessary before an action can commence in a United States District Court.

All photographs should have the photographer's copyright information as well as an identifying caption. This is easily done with a rubber stamp, a computer label or written by hand. Some photo labs have an imprinting service for color slides. There is computer software available that will allow you to print labels with the copyright notice as well as caption information. The copyright notice should read: copyright, date, and your name. The copyright symbol is most commonly used instead of writing out the word. The duration of a copyright is the photographer's life plus fifty years.

To register a copyright, write to Register of Copyrights, Library of Congress, Washington, DC 20559, telephone (202) 707-3000, and ask for form VA. The cost is $28.00 per registration. Bulk registration of photographs is permitted, and this can save you money. A 24-hour hot line for requesting forms is (202) 707-9100.

A legitimate publisher will request certain rights to an image for a specified usage and an agreed-upon sum of money. For example, a calendar publisher may want one-time use of a photograph. The publisher and the photographer agree upon an amount of money and the rights to use the picture for the year in which the calendar will be sold. The photographer can still sell the use of the photograph to someone else. Some publishers may not need the photograph for a project as large as a calendar, and may pay less to use the image. A magazine may want the use of a photograph for a cover. The magazine buys "One-time nonexclusive English language rights" for editorial usage to be published as a cover. If the photograph is used again inside the magazine the photographer receives an additional fee. Magazines pay for inside pictures based on the size of the reproduced photograph. For example, a photograph used in a double-page spread may bring as much as one used on a cover, while a ¼ page picture could bring less than $100. The photographer and the art buyer should always agree on, and understand, what rights are retained by the magazine.

An excellent source of information is the Stock Photography Handbook published by The American Society of Media Photographers, Inc., 14 Washington Road, Suite 502, Princeton, NJ 08550-1033.

Another publication listing buyers of photography is Photographer's Market, published by Writer's Digest Books, F&W Publications, 1507 Dana Avenue, Cincinnati, OH 45207.

MODEL RELEASES

A model release is simply a signed agreement between the photographer and the person being photographed stating that the photographer has the model's permission to publish the photograph. Pictures taken for advertising and for trade (book covers, etc.) must be released. This does not mean that a copy of the release must accompany the photography, only that you have a signed release on file. Always tell the publisher whether or not you have a release. Failure to do so can result in a lawsuit that could cost you and/or your publisher thousands of dollars. Pictures taken for editorial use are covered by the First Amendment to the U.S. Constitution, which guarantees freedom of the press. When in doubt, the best idea is to get a signed release.

Model releases can be bought at most camera stores, or you can make you own. As with any legal matter, if you are unsure about the wording of a release form, consult an attorney. Small model release forms can be printed on cards to be carried in your camera bag.

The following is one example of a model release:

POCKET RELEASE

For valuable consideration, I hereby grant_____(photographer's name) and his/her legal representatives and assigns, the irrevocable and unrestricted right to use and publish photographs of me, or in which I may be included, for editorial, trade, advertising and any other purposes and in any manner or medium; to alter the same without restriction; and to copyright the same. I hereby release

_____(photographer) and his/her representatives and assigns from all claims and liability relating to said photographs.

Name (print)_____Date_____

Signature_____Phone_____

Address_____

City_____State_____Zip_____

If minor, signature of parent/guardian_____

Witness_____

Reprinted from the ASMP forms guide published by the American Society of Media Photographers. Used with permission.

Glossary of Photographic Terms

Agfa. German manufacturer of photographic film, paper and chemicals. Founded in 1897, the company was originally called "Aktien-Gesselschaft fur Anilin-Fabrikation."

Agfachrome. The trade name of a family of transparency films manufactured by Agfa. Agfachrome films can be developed by the photographer or hobbyist, or by a commercial photo lab using Kodak E-6 or Agfaprocess.

Agfacolor. The trade name of a family of color negative films and photographic papers manufactured by Agfa. Agfacolor materials can be developed by the photographer or hobbyist, or by a commercial photo lab.

Agfapan. Agfa's family of black and white films.

Aperture. The opening in a lens through which light passes, controlled by an adjustable diaphragm (see *f*/stop).

Aperture Preferred. One mode of automatic exposure wherein the photographer selects the desired *f*/stop and the camera automatically selects the shutter speed based on the brightness of a scene (see Auto Exposure).

APO Lens. Apochromatic. A long-focal-length lens made of special optical glass and designed to focus the full spectrum of light, eliminating chromatic aberrations referred to as "lens flair."

ASA. The acronym for the American Standard Association. Once used as the standard by which the sensitivity of photographic film was rated. Commonly referred to as film speed. Replaced by ISO

(see ISO). ISO and ASA numbers are the same.

Auto Exposure. Exposures that are performed by the camera's computer, automatically, setting either the shutter speed or the *f*/stop, or both, determined by the brightness of reflected light either passing through the lens or falling on a sensor.

Autofocus. A camera lens that self-focuses by electronic circuitry and sensors. Also referred to as Electronic Focus or EF.

Automatic Lens. A lens that remains wide open during focusing and metering, stopping down to a selected *f*/stop during exposure. Not to be confused with automatic exposure or autofocus.

Available Light. Usually refers to natural daylight but can also mean light from an artificial source if the light is not provided by the photographer. Light from the sun, a window or a table lamp.

Background. The portion of a photograph behind the main subject.

Backlight. Light falling on the back of the subject when the subject is between the camera and the light source and facing the camera.

Ball Head. A ball and socket tripod head that allows the camera to be tilted at any angle.

Bellows. The flexible accordion-like part of a view camera between the lens and camera body. Also an extension device for 35mm cameras used to take extreme close-up photographs.

Bracketing. Additional exposures at different *f*/stops, or different shutter speeds, from what is determined to be the correct exposure. Used to ensure exact exposure or for visual effect.

Bulb. Shutter setting in which the camera's shutter remains open as long as the release button is held down. The shutter closes when the button is released. Can be used to make multiple flash exposures at night. Originally used to hold open a shutter while a flashbulb was set off (see Flashbulb).

Cable Release. A flexible encased cable used to trip the camera shutter.

Camera Angle. The point of view from which a subject is photographed.

Close-up. A view that is closer than a normal viewing distance. Also a magnified view of a small object (see Macro).

Close-up Lens. An auxiliary lens that is attached to the front of a camera lens that allows the lens to focus at a shorter than normal distance from the subject. Often used in combinations of different values. Not to be confused with a macro lens.

Color Temperature. The color of light measured in degrees Kelvin (K) (see Kelvin).

Composition. The placement of elements in a photograph to achieve balance and unity that is pleasing to the eye.

Contrast. The difference in the brightness of tones in a scene. In black and white photography it describes the range of tones of a negative or print. High contrast is mostly black and white with little or no gray. Low contrast is mostly gray with little black or white. In color photography it can describe the lighting.

Copyright. Indicates the ownership of a photograph, song, book or story. Indicated by the symbol ©, name and year.

Crop. Removing unwanted parts of a picture by moving the camera closer to the subject or by framing the scene tighter than normal in the darkroom.

Daguerreotype. The first permanent photograph, invented in France by Joseph Nicephore Niepce and Louis Jacques Mandé Daguerre and introduced by Daguerre in 1839.

Daylight Film. Film designed to be used with natural outdoor light or electronic flash. Daylight film is color balanced to 5500 degrees K.

Dedicated Flash. An electronic flash that is designed to be used on a specific camera. Exposure is determined by electronic circuitry in both the camera and the flash.

Depth of Field. The degree of sharpness of a photograph determined by the *f*/stop at which the exposure was made. The area of sharpness in front of and behind the point of main focus.

Developer. The first chemical in the process of developing photographic film and paper.

Diaphragm. An adjustable device inside the lens used to control the size of the aperture.

Digital Photography. Photography without film using specially designed cameras or camera backs. Images are captured electronically and processed by a computer.

E-6. Eastman Kodak's process for developing Ektachrome slide films. Slide films manufactured by other companies can also be developed using the E-6 process.

Eastman, George. Inventor of flexible photographic film and founder of the company that became Eastman Kodak.

Ektachrome. The trade name of a family of transparency films manufactured by Eastman Kodak Company. Ektachrome films can be developed by the photographer or hobbyist, or by a commercial photo lab.

Ektacolor. The trade name of a family of color negative films and photographic papers manufactured by Eastman Kodak Company. Ektacolor materials can be developed by the photographer or hobbyist, or by a commercial photo lab.

Electronic Flash. A lighting device that has a glass tube filled with xenon gas that produces a bright flash of light when triggered by a brief discharge of high-voltage electricity.

Emulsion. The light-sensitive layer of chemicals on the surface of film.

Extension Tube. A device that mounts between the lens and camera that extends the focusing range of a lens for close-up photography.

Exposure. The taking of a picture. One frame of film. Allowing light to reach the film inside a camera by means of a lens and shutter. The length of time that light is allowed to strike the film to create an image.

Exposure Meter. An instrument used to measure the intensity of light and to indicate the settings on a camera for correct exposure.

***f*/Stop.** The numerical description of aperture openings on a camera lens.

Film. The flexible light-sensitive material used inside a camera to record photographic images.

Film Speed. See ISO.

Film Magazine. A device that holds roll film for insertion into a camera.

Filter. Transparent, colored, lenslike accessories that attach to the camera lens and absorb certain colors and transmit others. Used to correct or enhance a photograph. Usually made of glass.

Filter Factor. The mathematical formula used to calculate exposure adjustments for the amount of light absorbed by a filter.

Flash Bulb. Special light bulbs that give off very bright light for a brief period of time, used one time and discarded. Seldom used today.

Focal Length. The numerical designation of the magnifying power of a lens.

Focus. Adjusting the lens for a sharp image at different subject-to-camera distances.

Focus Free. Refers to a simple camera with a fixed lens that is not adjustable.

Fuji. Japanese manufacturer of film, paper and cameras.

Fujichrome. The trade name of a family of transparency films manufactured by Fuji. Fujichrome films can be developed by the photographer or hobbyist, or by a commercial photo lab using Kodak E-6 or Fuji CR 56 process.

Grain. The uneven distribution and overlapping of silver particles in film causing the print or slide to appear to have a texture when highly enlarged.

Gray Card. A card with a shade of gray that reflects 18% of the light striking its surface. Used to determine correct exposure.

Guide Number. A number used to calculate manual flash exposure to determine distance or f/stop.

Haze Filter. See ultraviolet filter.

Image. Refers to any scene on film.

Incidence Light Meter. An instrument that measures the intensity of light falling on a surface.

Internegative. A color or black and white negative made from a color slide or large transparency.

Kelvin, Lord William Thomson (1824–1907). British physicist who introduced the Kelvin thermodynamic scale on which absolute zero is equal to -273 degrees Celsius. The color of light is measured in degrees Kelvin (K).

Kodachrome. Slide film manufactured by Eastman Kodak Company. Kodachrome must be processed (developed) by a custom photo lab and not by the photographer.

Large Format. Refers to large cameras and to large sheet-film. Any camera that requires 4x5 inch or larger film.

Latitude. The usable range of over and under exposures of film.

LED. Light Emitting Diode that forms bright numbers in electronic instruments.

Lens Cap. Hard plastic or metal protective cover for a lens. Some lens caps screw on, others snap onto the lens.

Lens Coating. A chemical coating that reduces the amount of flair in a lens. Applied at the time of manufacture.

Lens Element. One of several glass optical parts inside a lens.

Lens Flair. The result of light striking the front of a lens and degrading the image on film.

Lens Hood. Also called lens shade. Attached to the front of the lens to prevent light from striking the lens surface causing lens flair and loss of contrast.

Lens Opening. See Diaphragm and f/Stop.

Light Fall-off. The diminishing of light as it gets farther from its source or when it is absorbed by water.

Macro Lens. A lens designed to be used for close-up as well as normal photography.

Manual Exposure. Camera settings determined and performed by the photographer for correct film exposure.

Manual Flash. Nonautomatic flash exposures determined by a flash meter or guide numbers.

Microphotography. Taking pictures through a microscope.

Model Release. A legal document signed

by a model giving the photographer written permission to publish his or her picture.

Mirror Lens. Lens equipped with a group of mirrors instead of lens elements resulting in a telephoto lens that is physically small. Mirror lenses have only one *f*/stop.

Normal Lens. A lens with a focal length approximately the same as the diagonal measurement of the film image. Used as a standard lens.

Optics. The branch of physics that deals with the transmission of light through lenses.

Overexpose. To allow too much light to reach the film.

Pan. To follow a moving subject with the camera.

Photometer. See Exposure Meter.

Rangefinder. Device in which a set of mirrors inside the camera enables the photographer to focus the lens.

Shutter. Moving curtain inside a camera or lens that opens and closes at different lengths of time to expose film.

Shutter Speed. The length of time a camera shutter remains open.

SLR. Single Lens Reflex camera. A camera that uses a mirror and prism arrangement to view, focus and take the photograph through one lens.

Spot Meter. An exposure meter that has a lens through which light from a small part of a scene is measured.

Telephoto Lens. Lens of long focal length that can make close-up pictures of a distant scene.

Twin Lens Reflex. A camera that has two lenses of matched focal length. One lens is used to view the scene, the other lens takes the picture.

Ultraviolet Filter (UV). Filter that absorbs excessive ultraviolet rays and lessens the effect of atmospheric haze.

Underwater Housing. Watertight, box-like container to protect a camera for underwater photography.

Underexpose. To permit insufficient light to reach the film.

Variable Focus Lens. See Zoom Lens.

View Camera. Large camera that takes 4x5 or 8x10 film.

Viewfinder. Window in a camera through which the photographer frames a scene.

Viewing Screen. Ground-glass element in a camera onto which the scene is focused.

Waist Level Viewfinder. Found in twin-lens-reflex and some single-lens-reflex cameras. It allows the photographer to view the subject from the top of the camera.

Wide-Angle Lens. A camera lens with a broader field of view than the human eye.

Winder. Powered film-advance device that attaches to a camera.

X-Sync. X-Synchronization. The speed at which the camera's shutter synchronizes with the light from an electronic flash.

Zoom Lens. A lens with internal moveable elements that can be adjusted for multiple focal lengths.

Associations and Organizations

PHOTOGRAPHIC

**American Photographic
Historical Society, Inc. (APHS)**
1150 Ave. of the Americas, New York, NY
10036

**American Society of
Camera Collectors (ASCC)**
4918 Alcove Ave., North Hollywood, CA
91607

**American Society of
Media Photographers (ASMP)**
Washington Park, Ste. 502, 14 Washington Rd., Princeton, NJ 08550-1033

**Association of Professional
Color Laboratories (APCL)**
3000 Picture Place, Jackson, MI 49201

Biological Photographic Association
1 Buttonwood Ct., Indianhead Park, IL
60625

Greeting Card Association
1200 G St. NW, Ste. 760, Washington,
DC 20005

**International Association of
Panoramic Photographers (IAPP)**
1739 Limewood Ln., Orlando, FL 32818

**National Association of
Photographic Manufacturers (NAPM)**
550 Mamaroneck Ave., Harrison NY
10528

**National Press Photographers
Association (NPPA)**
3200 Croasdaile Dr., Ste. 306, Durham,
NC 27705

Photographic Collectors of Houston
P.O. Box 70266, Houston, TX 77270

Photographic Society of America (PSA)
300 United Founders Blvd., Ste. 103, Oklahoma City, OK 73112

Professional Photographers of America, Inc. (PPA)
57 Forsyth St. NW, Ste. 1600, Atlanta, GA 30303

Society for Photographic Education
Box BBB, Albuquerque, NM 87196

Western Photographic Collectors Association
P.O. Box 4294, Whittier, CA 90697

OUTDOOR ASSOCIATIONS AND ORGANIZATIONS

African Wildlife Foundation
1717 Massachusetts Ave. NW, Washington, DC 20036

African Wildlife News Service
P.O. Box 546, Olympia, WA 98507

American Association of Zoological Parks and Aquariums
7970-D, Old Georgetown Rd., Bethesda, MD 20814

American Birding Association
P.O. Box 6599, Colorado Springs, CO 80934

American Cave Conservation Association
P.O. Box 409, Horse Cave, KY 42749

The Garden Club of America
598 Madison Ave., New York, NY 10022

National Audubon Society
700 Broadway, New York, NY 10003-9501

National Council of State Garden Clubs
4401 Magnolia Ave., St. Louis, MO 63110

National Geographic Society
17th and M Sts. NW, Washington, DC 20036

National Wildlife Federation
1400 16th St. NW, Washington, DC 20036

Outdoor Writers Association of America, Inc.
2017 Cato Ave., Ste. 101, State College, PA 16801

Sierra Club
730 Polk St., San Francisco, CA 94109

World Wildlife Fund
1250, 24th St. NW, Washington, DC 20037